BASIC TECHNIQUES & EXERCISES

BASIC TECHNIQUES & EXERCISES

Painting Figures and Portraits in Watercolour

José M. Parramón

This edition first published in the United Kingdom in 1999
by Ediciones Lema, S.L.

Original Spanish edition
Editor: José M. Parramón
Text: José M. Parramón and Gabriel Martín
Production, layout, and dummy: Ediciones Lema, S.L.
Cover: Award
Photochromes and phototypesetting: Adría e Hijos, S.L.
© José M. Parramón
© Ediciones Lema, S.L. All rigths reserved of production

ISBN 84-89730-76-8
Printed in Spain

Table of Contents

1

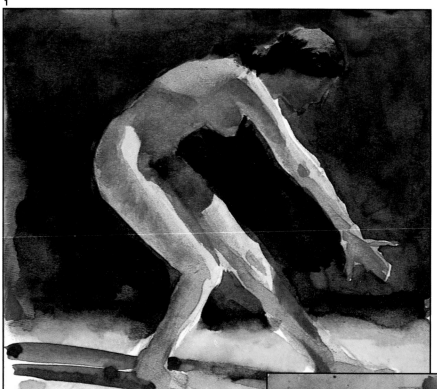

Figs. 1, 2. I painted these two watercolour studies on two separate occasions, using two different models.

The one above was painted during a studio session with a nude model who struck many poses, this being one of my favorites.

The painting on the right began as a sketch made at a summer party where Ana, the daughter of a friend, did a ballet dance. I thought the drawing I made while she danced had potential as a painting, so I asked Ana if she would come to my studio and pose in her ballet costume, then I made a number of sketches before settling on this graceful dance position.

2

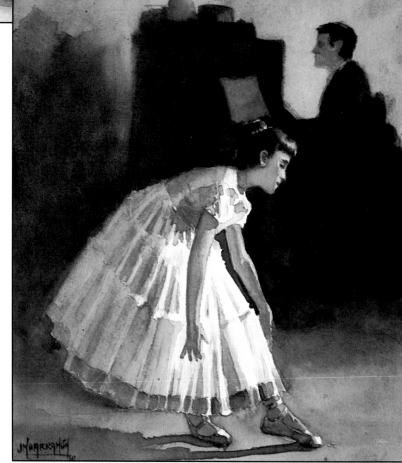

The writer and critic Rene Huyghe, former honorary head curator of The Louvre in Paris, writes in his book *Dialogue with Art,* "Whether it is a source of beauty or a simple projected image, art goes beyond all superficial activities or games of relaxation or pleasure. In either case, art puts the deepest conditions of our existence to the test."

Welcome to the fascinating world of art in general and watercolour painting in particular. Working in this medium, you will meet with exciting challenges in each and every painting that you create. Through the constant practice of watercolour technique, your painting can become something instinctive, so much an extension of yourself that you'll end up handling the brush with no conscious thought. But the need to practise is essential, particularly to master applying a basic watercolour wash. To quote one authority, painter-author Edgar A. Whitney, "Seventy-five percent of watercolour painting technique consists of attaining the skill to paint a wash." In the following pages, you'll learn about washes and value scales used in portraying the human figure and face.

You'll also learn to apply rules that govern how to draw correct proportions for the head and body, the total height from head to toe being equal to eight times the height of the head. In practising the rules of proportion, you'll draw and paint the human figure using a flexible wooden manikin as your model, and you'll also work on drawing the human head in different positions.

But don't forget that above all, and like any other motif painted in watercolour, figures and portraits require a foundation in the art of drawing. This is a necessity that Vincent van Gogh alluded to when he wrote in one of his letters to his brother Theo, "I plan to draw many sketches of the figure. If fifty sketches aren't enough, I'll draw one hundred or even more, until I truly achieve what I'm trying for. I will also learn to paint portraits, but that will only come through drawing a lot—not a single day without some drawing."

The exercises contained in this book will give you the chance to draw and paint the figure both clothed and in the nude, following examples presented in step-by-step demonstrations. Also ask friends and relatives to pose for you. All serious artists know that painting from life is essential. As a very young man, Claude Monet drew caricatures, but one day he ran into the Impressionist Eugène-Louis Boudin, who said, "Why don't you try painting?" They went together to his studio to paint from live models. Boudin declared, "Everything that is painted directly from a live model has a force and an energy, a liveliness of touch, which is not to be found by copying or by painting in the studio without a model." From that day forward, Monet always painted from a live model.

When we explore the art of portraiture, exercises in this book include painting from life, having an adult or child pose for you. The great portraitist Jean-Auguste-Dominique Ingres gave his pupils this advice about painting from life: "Work on all parts of the painting at the same time. An expert must have his eyes on everything at once, and harmonise and adjust it all up until the very last minute." He also said, "Draw the eyes as you go." I interpret this to mean that you should draw the eyes in a series of brief attempts or stages, without concentrating so much on outlining and shaping the iris, pupil, or eyelashes all at once. The ideal thing, according to Ingres, is to "draw as you go," without stopping too long to work on one feature. Work on one eye and then leave it alone for a while, going on to the hair or the mouth. Then go back to the eye, then to the nose, then back to the eye, stage by stage.

Don't be discouraged if the figure or portrait doesn't come out just right

Fig. 3. José M. Parramón has written more than forty books on art instruction, which have been translated into many languages and published in countries on three continents.

on your first try. History tells us about many artists who weren't always satisfied with their work. Michelangelo used his hammer to destroy more than one of his sculptures that didn't match the vision he had seen in his mind's eye. Paul Cézanne saw in each of his paintings only a process, a starting point in the search for new pathways. I encourage you to adopt that approach to your watercolour creations.

José M. Parramón

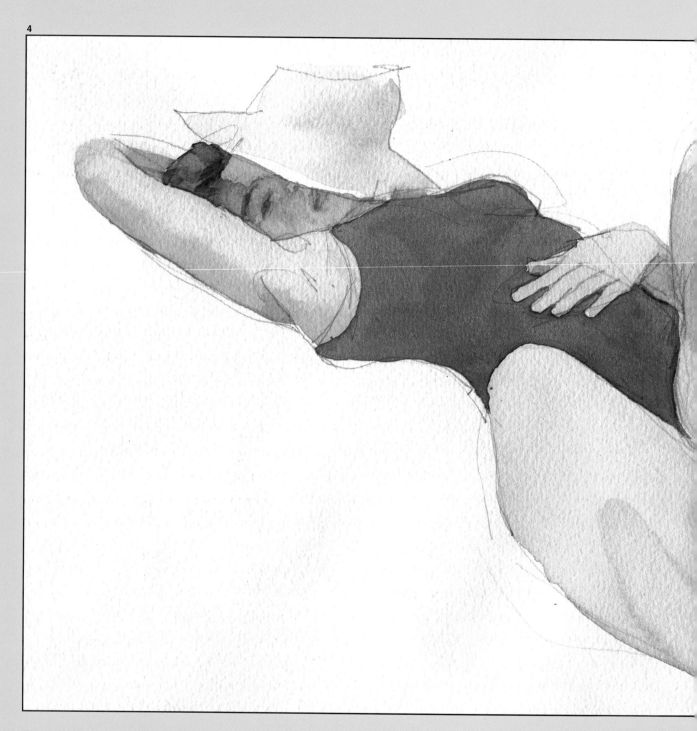

Fig. 4. Learning the relative proportions of different parts of the body and how to ensure that those ratios are correctly depicted, regardless of body position, will give you the confidence to draw and paint figures in standing, seated, or action poses.

PAINTING CORRECT FIGURE PROPORTIONS

From antiquity, artists have shown concern for formulating mathematical equations to determine the measurements of the ideal human figure. In these first chapters we'll take a look at the better-known of the classical rules of proportion for the human figure, a challenging theme. This should allow you to learn the basics in portraying the human body: format, proportions, pose, anatomy, the effects of light and shadow, and so on. It was Jean-Baptiste-Camille Corot who said, "Above all, the drawing has to be just right." Without a knowledge of the basics described here, it is almost impossible to paint the human figure correctly.

Proportions of the Male Figure

The representation of the human figure is one of the most challenging of pictorial genres. This is because the interpretation of the male or female figure requires a knowledge of anatomy and the application of rules of proportion based on mathematical equations that establish the correct measurements in drawing the body.

The problem of representing the ideal proportions of the human figure was posed as early as classical antiquity by sculptors like Polyclitus, Praxiteles, and Leochares. We owe to these thinkers the best-known rules of proportion that have been widely accepted throughout the history of art.

In the fifth century B.C., Polyclitus established a rule that divided the human body into a number of equal parts so that it could be drawn in a unified and balanced way. In his treatise on the subject, Polyclitus wrote: "In order to proportion the parts of the body perfectly, the figure should be seven and a half heads tall." Each of the equal parts, one head high, is called a unit. Polyclitus applied his rule of seven and a half heads or units to all his sculptures, which became the best examples of the precept. Among them is the famous sculpture *Doryphorus*—also called *The Canon* because of its strict adherence to this rule of proportions (fig. 5). Polyclitus' rule was accepted by most artists of the era; it determined the style and features characteristic of what is called the classical period.

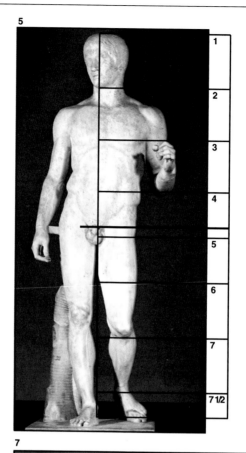

5

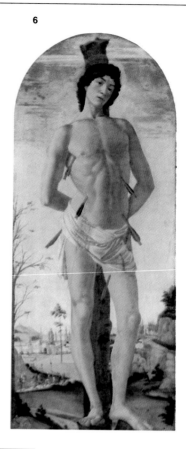

6

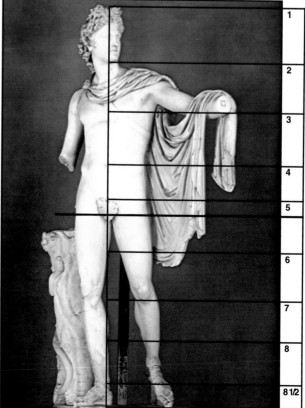

7

Fig. 5. **Doryphorus** *exemplified the great Greek sculptor Polyclitus' theory that the ideal human body is seven and a half times the height of the head.*

Fig. 6. **Saint Sebastian** *by Botticelli reflected one Renaissance theory that described the ideal figure as equaling nine heads in height.*

Fig. 7. *The* **Apollo Belvedere** *by Leochares was based on the rule of eight and a half heads in height.*

A century later, another sculptor, Praxiteles, established a new idealisation of the human body, more slender than the previous one. He said that the total height of the ideal body was eight times the height of the head. Still another sculptor, Leochares, spoke through example by sculpting his famous *Apollo Belvedere* (fig. 7) based on a rule of eight and a half heads.

During the Renaissance, twenty centuries later, artists continued to debate which was the best way to represent the body proportionally, but could not reach a consensus agreement. While Michelangelo based his *David* on Polyclitus' rule of seven and a half heads, Leonardo conceived a revised rule based on eight heads, and Botticelli went as far as nine heads (fig. 6, opposite).

It wasn't until the beginning of this century that research scientists confirmed eight heads as the ideal proportion, arriving at that conclusion by analyzing a group of selected individuals—tall, athletic, well-proportioned males. Upon calculating an average, the same rule arrived at centuries earlier was affirmed when they declared a ratio of eight heads to the total height of the body as ideal (fig. 8).

From an artistic point of view, it's obvious that any of the rules of proportion described here can be used, but there's no doubt that the rule best matching the aesthetic norms of our times is that of eight heads.

Fig. 8. The number of units for the male figure generally used by artists today is a total of eight in height and two in width.

8

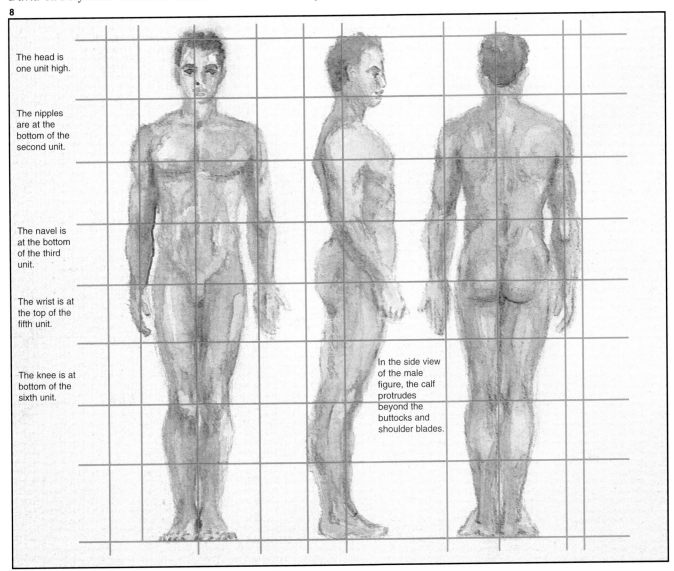

The head is one unit high.

The nipples are at the bottom of the second unit.

The navel is at the bottom of the third unit.

The wrist is at the top of the fifth unit.

The knee is at bottom of the sixth unit.

In the side view of the male figure, the calf protrudes beyond the buttocks and shoulder blades.

Female and Children's Figures

The rules of proportion for female and male figures are similar, but anatomical differences between the genders affect proportions in a number of ways; the drawings below (fig. 9) illustrate the following points:

a) On average, the female figure is shorter than the male by about four inches.

b) A woman's shoulders are generally narrower than a man's.

c) Nipples are lower.

d) The waist is narrower.

e) The navel is lower.

f) Hips are wider.

g) When the female figure is seen in profile, it's the buttocks that protrude beyond the vertical line, while in the male figure, it's the calves.

Finally, the shape of the woman is generally made up of softer, less solid contours than that of the man.

Fig. 9. The eight-unit rule of proportion also applies to a woman's form, but the female is generally shorter, narrower across the shoulders, and wider across the hips than the male. Some parts of the body are located at the same unit points while others are not.

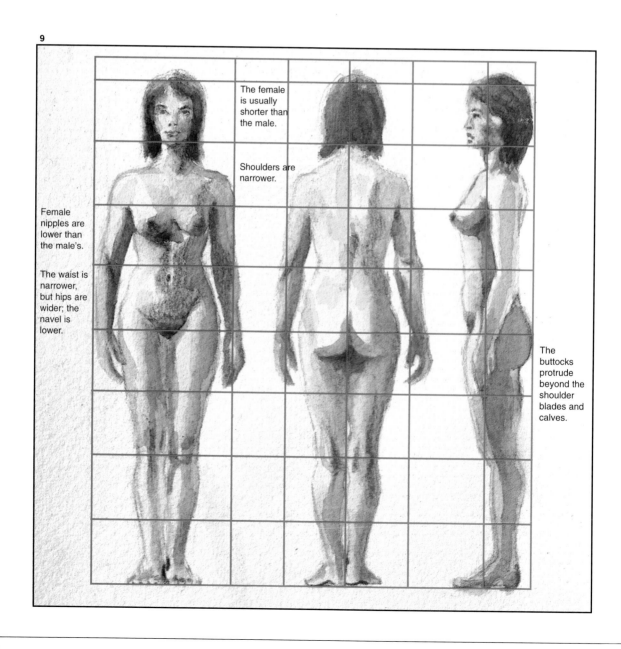

9

The female is usually shorter than the male.

Shoulders are narrower.

Female nipples are lower than the male's.

The waist is narrower, but hips are wider; the navel is lower.

The buttocks protrude beyond the shoulder blades and calves.

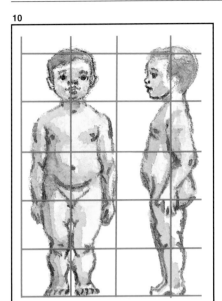

Fig. 10. A five-unit rule of proportion applies to a two-year-old. This chubby image is reminiscent of the cherubs commonly seen in paintings of the Renaissance and Baroque periods.

Up to this point, I've been describing the bodily proportions of adults. But what about the body of a child or an adolescent? What rules apply to them? In the first place, it's not just a question of drawing a smaller version of the adult figure of eight heads. The drawing of a child's body or an adolescent's each follows its own formula. The secret for understanding this formula lies both in the head (a part of the body that grows the least) and the extremities (parts that grow the most). We are born with big heads, pot bellies, and short legs. The younger the person, the bigger the size of the trunk and head in relation to the extremities.

Consistent with these guidelines, proportions for the newborn should be the height of four heads, or four units. Proportional to the rest of the body, the head is almost twice as big as that of the adult male. The trunk and arms of newborns measure the same propor-

tionally as that of the adult, but the legs are markedly shorter. The body is relatively chubby, and there are marked folds of skin at the joints.

By the age of two, the physical makeup of the baby has changed in several ways. The rib cage has begun to develop and to become considerably larger in relation to the extremities, and as you can see, we have gone from a rule of four units to a ratio of five (fig. 10).

Between ages two and six, the legs grow more quickly and the body reaches six units. The trunk also widens and lengthens, its proportions coming to look more like those of the adult body (fig. 11, center).

The body of a well-built twelve-year-old boy is seven heads tall (fig. 11, right). The legs have grown to three units by now. But the pectoral muscles and muscular mass in general are not fully developed at puberty, so the body looks somewhat feminine. When development from adolescence to maturity occurs, it is characterised by further growth of the legs, which go from three units to four.

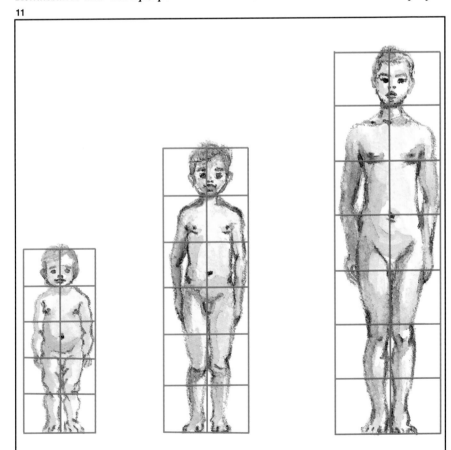

Fig. 11. As children grow and their body proportions change, height moves from five units to seven.

Contrapposto and Action Figures

A figure's posture or movement hinges on the position adopted by the hips, or more precisely on the part of the hipbone called the ischium.

The contrapposto position, a pose often seen in classical Greek and Roman sculpture, places the weight on one straight leg, with the other bent. The torso is twisted in one direction, while the lower body twists in the other. As illustrated by the skeletons below (fig. 13), at left we see a skeleton in a frontal position with body weight evenly distributed so that hipbones are aligned. The skeleton on the right is in a contrapposto position with the weight on one leg while the other is relaxed; hips and torso are orientated opposite one another.

Whenever you draw a figure, keep these points in mind, particularly considering the position of the hips.

Fig. 12. The contrapposto position is evident in **Nude Girl with Black Hair** *by the Austrian artist Egon Schiele.*

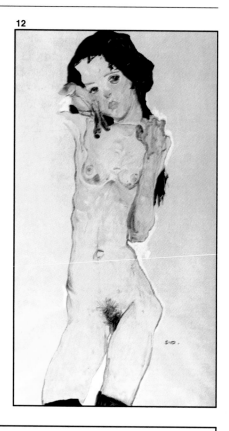

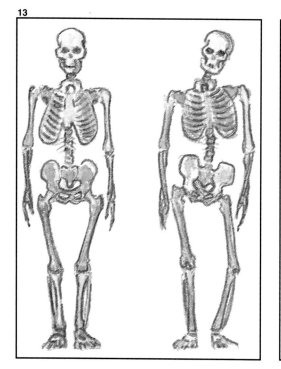

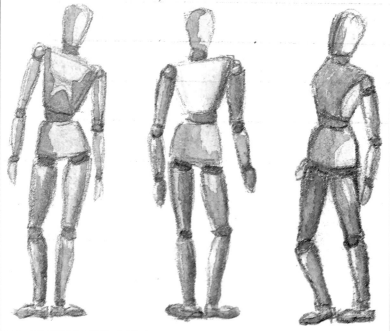

Fig. 13. By examining a picture of the human skeleton, we can see what happens when the model adopts the contrapposto posture: *the hips tilt to one side, the torso tilts to the opposite direction.*

Fig. 14. The contrapposto posture in manikins is shown from different perspectives.

The same sort of thing happens when you draw the human figure in motion. When depicting a figure walking or running, always keep in mind the position of the pelvis, as shown in various examples below (fig. 15).

Practise action figures by drawing the illustrations shown here, observing what's happening to the pelvis in each case. It's not necessary to draw the figures in great detail; only draw simple geometric forms in which the torso, pelvis, neck, head, and extremities can be clearly identified. Once you have enough practice at this, you'll be able to imagine new movements or postures and apply what you've learned to them.

Fig. 15. Studying the human figure in motion can help you to understand how the torso and hips shift as the body assumes different positions.

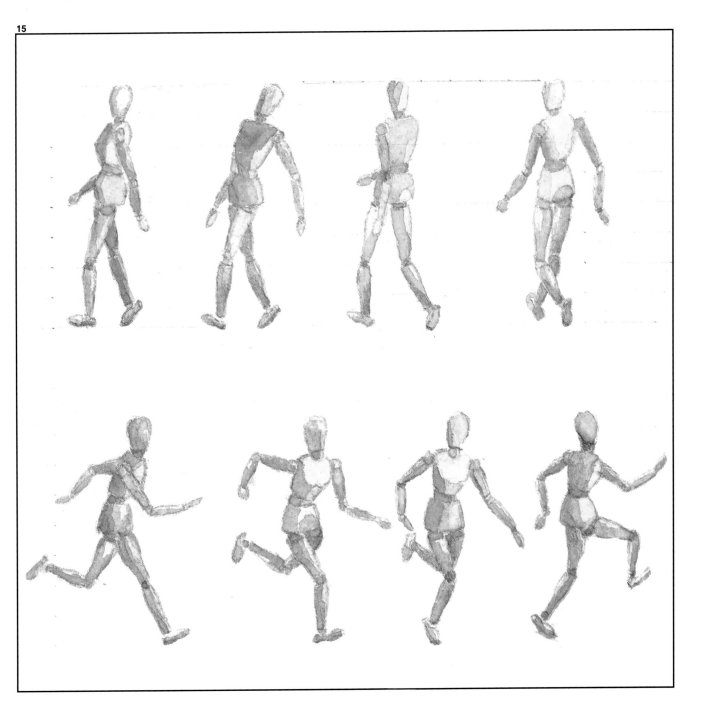

The Movable Manikin

The hinged wooden manikin (fig. 16) hasn't changed much for centuries; it's practically the same as the one used by the great masters of Renaissance painting. One of the oldest manikins still in existence was made in the sixteenth century (it can be seen in the Staatliche Museum in Berlin), but manikins are believed to have been used from the fifteenth century on. The manikin shown is made of carved wooden pieces hinged together to represent the human figure. The joints can be moved to reproduce all kinds of poses, but the manikin can't be put into any position a person couldn't normally get into. For example, you can't bend a joint in the wrong direction or tilt the head or hips more than humanly possible.

The manikin most often used is about a foot tall and can be found in art shops. This tool is usually expensive, but extremely useful. If possible, practise with a manikin, as Ester Llaudet has done in this series of sketches (figs. 17, 18, 19), by showing the manikin in various postures. Start by making a line drawing in pencil. Once you've established basic shapes and proportions, apply a simple monochromatic wash. If you practise daily, you'll soon learn to structure and proportion the human figure correctly.

16

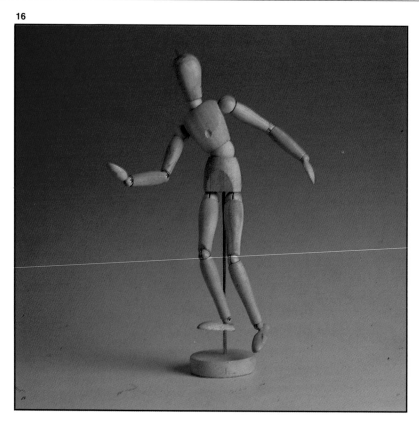

Fig. 16. A hinged wooden manikin, available at most stores that sell art supplies, is a valuable tool to have in your studio.

Figs. 17–19. Making studies of a manikin in various positions is excellent preparation for creating figure paintings.

17

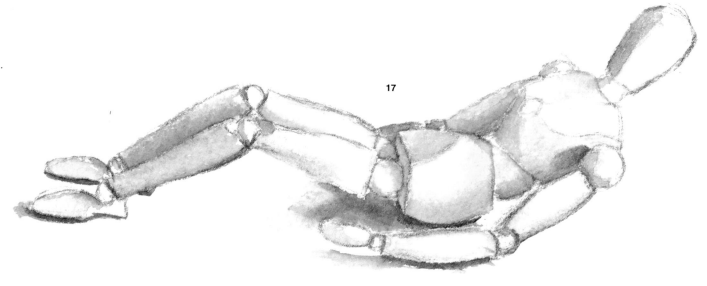

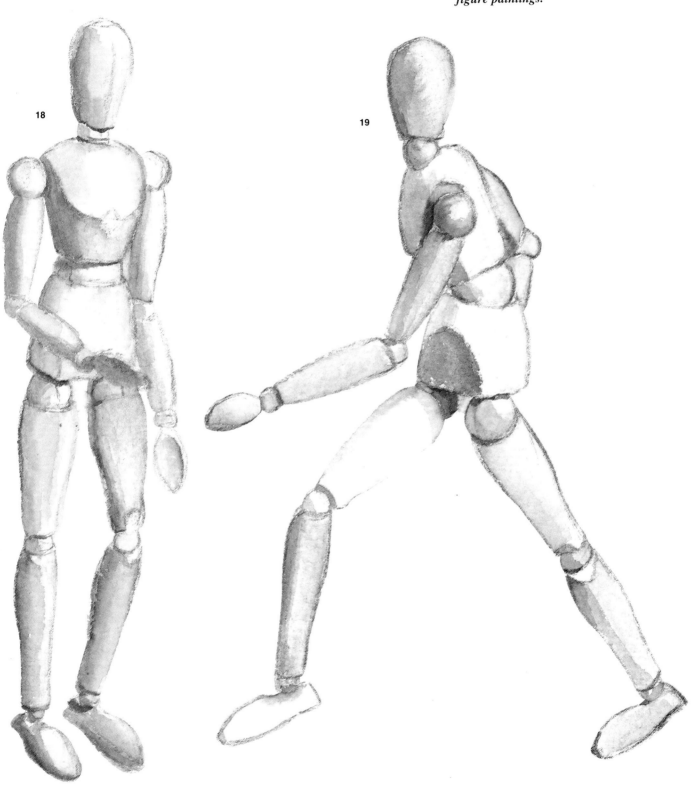

Figs. 17–19. Making studies of a manikin in various positions is excellent preparation for creating figure paintings.

18

19

Anatomy: Houdon's *Écorché*

Jean-Antoine Houdon's *Écorché* is among the classical sculptures used since the eighteenth century for studying the location of muscles and tendons in the human body. As you know, the muscles are fleshy parts of the human anatomy made up of a fibrous tissue that contracts when ordered to do so by the nervous system. As illustrated (figs. 20, 21), muscles vary widely in shape. They're named either for their shape (deltoid, trapezius), function (adductor, extensor), location (pectorals, dorsal), direction of movement (abdominal oblique, rectus abdominis), or makeup (semimembranous, semitendinosus).

20

STERNOCLEIDOMASTOID
TRAPEZIUS
DELTOID
PECTORALIS
SERRATUS ANTERIOR
BICEPS

ABDOMINAL OBLIQUE
RECTUS ABDOMINIS
PRONATOR
SUPINATOR
PALMARIS
PALMARIS LONGUS
TENSOR FASCIA LATA
PECTINEUS
ADDUCTOR
SARTORIUS
RECTUS FEMORIS
VASTUS MEDIALIS
VASTUS LATERALIS
PATELLA
GEMELIS
TIBIA
TIBIALIS ANTERIOR
EXTENSOR DIGITORUM

Fig. 20. A frontal view of Houdon's Écorché with many of the muscles and tendons labeled. While you would rarely want to describe musculature so specifically in your watercolour paintings, it will be helpful to you, as a well-rounded artist, to refer to classical studies such as this when portraying body contours in your figure work.

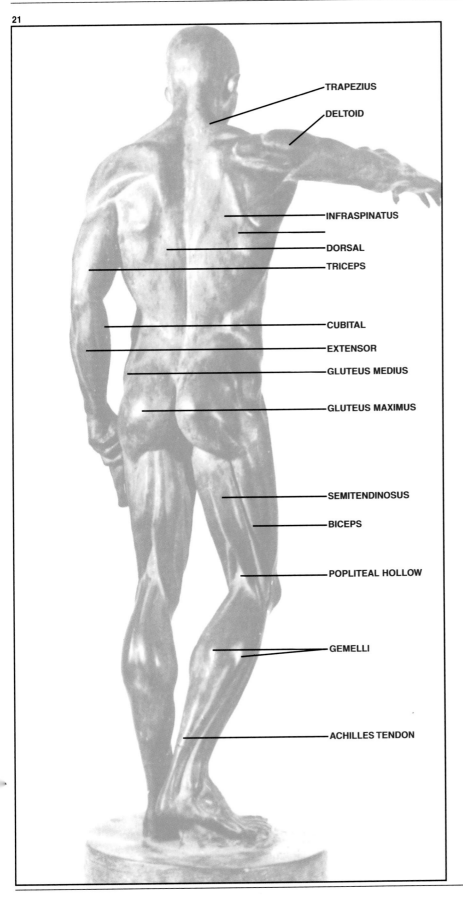

TRAPEZIUS

DELTOID

INFRASPINATUS

DORSAL

TRICEPS

CUBITAL

EXTENSOR

GLUTEUS MEDIUS

GLUTEUS MAXIMUS

SEMITENDINOSUS

BICEPS

POPLITEAL HOLLOW

GEMELLI

ACHILLES TENDON

Most muscles come in pairs and almost all are attached at the ends to bones.

Notice how the long muscles are distributed on the extremities, while the wider muscles occupy most of the surface of the torso.

Take a sheet of paper and try sketching the frontal and dorsal views of Houdon's *Écorché*, defining the lines that show muscle contours, which will help you to remember their location and shape. Study the shape of each muscle as well as the changes they go through according to the posture of the body. For example, compare the deltoids and the pectorals in the outstretched arm with their usual position when at rest with the arm hanging down.

Fig. 21. A dorsal view of the same sculpture presents an excellent reference for painting human figures seen from the rear. Keep the structure of the body in mind even when portraying fully clothed figures, as it will help you to portray a more realistic and natural flow of fabric over the underlying form.

Light and Shadow on the Human Figure

The amount, quality, and direction of light play a decisive role in promoting the illusion that the painting of a human body has volume.

The amount of light: The contrast between the shadowed and lighted areas of a figure is important. If we put a 25-watt bulb close to the model, it will cast much sharper shadows than would be seen under natural light.

The quality of light: Tonal gradations and contrasts between light and shadow are influenced by light quality. There are two kinds of lighting: direct light, when natural or artificial light falls directly on the model, and diffused light, which is indirect and gives the model a less defined shadow.

The source of light: There are five different possibilities:

Frontal light: Reaching the model from the front, it produces almost no shadows (fig. 22).

Sidelighting: Lights are thrown on the model from one side, projecting a shadow on the other side. This kind of light produces a greater contrast between lighted and shadowed areas (fig. 23).

Lighting from above: The source of the light is located above the model, producing an ideal quality for drawing or painting (fig. 24).

Lighting from below: This is not a very common kind of lighting, since the source of the light is located below the model, often adding a dramatic and mysterious aura (fig. 25).

Backlighting: Light reaches the model from the back and darkens the plane closest to the artist (fig. 26).

22

23

24

25
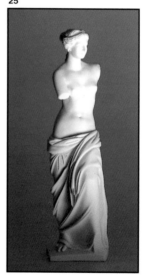

26
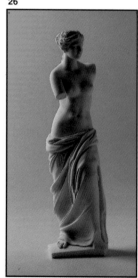

27

Figs. 22–26. Five classical examples of lighting for the human figure are: from the front (22), the side (23), overhead (24), below (25), behind (26).

Fig. 27. When portraying the effects of light and shadow on a human figure, the artist gives areas in shadow an overall shading first, then defines each area more specifically.

Watercolour Sketches of Figures

Watercolour sketches of figures try to capture momentary observations and evoke spontaneity, imagination, and originality. Sketching helps us to remember that drawing is a constant search, a process through which we discover meaningful and aesthetically pleasing poses. Even as sketching yields us a coherent representation of the model and an analytical approach to its structure, it improves the artist's drawing skills.

In learning to draw, the most important thing is to learn to observe. Sketching affords you the opportunity to observe and understand the shapes found in nature. Only through this observation will you manage to connect your eye, mind, and hand.

When sketching, you have to ignore details and pay more attention to interpreting the model. In other words, draw only the largest features, giving shape to the figure through a few loose strokes that are both quick and wide.

Sketching from a live model, as opposed to a photo, allows you to see volume and contours much more fully. It's also excellent preparation for painting models and making your own decisions, rather than accepting those in a photo, on format, composition, contrast, and interpretation.

The works by Merche Gaspar that illustrate this chapter are fine examples to follow. Most were created on small blocks of watercolour paper usually measuring 4 x 6" (11 x 16 cm), which the artist always takes along wherever she goes and on which she draws and then paints whatever attracts her attention. In them you can see the freshness and spontaneity with which she depicts the human figure.

28

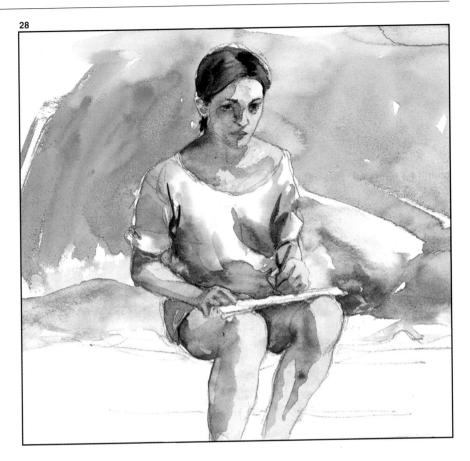

29

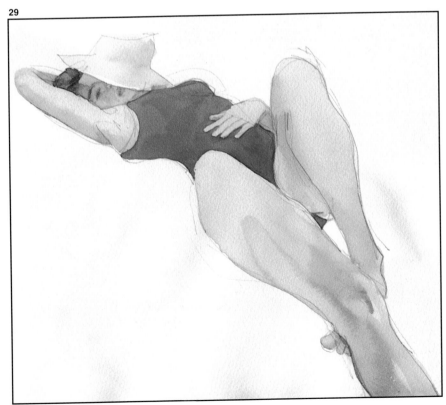

Figs. 28, 29. Two appealing watercolour studies of the human figure by Merche Gaspar show a woman seated on a bed and a sunbather stretched out on a beach.

Before ending this chapter, I want to stress again that you'll need to make a lot of sketches in order to acquire dexterity in the art of drawing, which is the basis of a good watercolour painting. You can start by using printed images or photos as models; later on, try to use live models. The choice of a theme should not be an impediment, since whomever you happen to see as you walk down the street might serve as a model for impromptu sketching.

Most places as good for sketching. Take a sketch pad with you wherever you go and practise at home using your relatives or friends or draw strangers on buses, in parks, on the beach, sitting at an outdoor café, or wherever. Of course, people you see on the street rarely stay still for long, so this can be a good exercise in making very quick sketches.

Follow your impulse to draw and dare to practise anywhere. In order to get good results, you'll have to do this as often as possible, so practise, practise, practise.

30

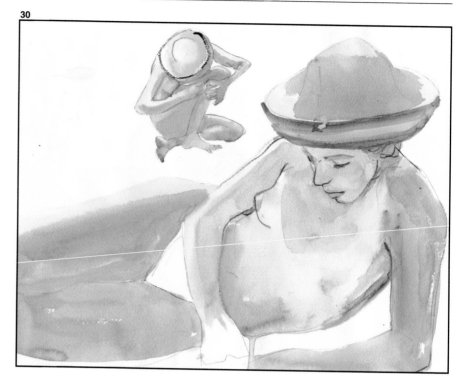

Figs. 30–32. Merche Gaspar always carries a block of watercolour paper with her on which to make sketches. Above, two views of the same woman relaxing on a beach; below, a friend taking a nap; opposite, rendered in a monochromatic wash, a young woman gazing out of a window.

31

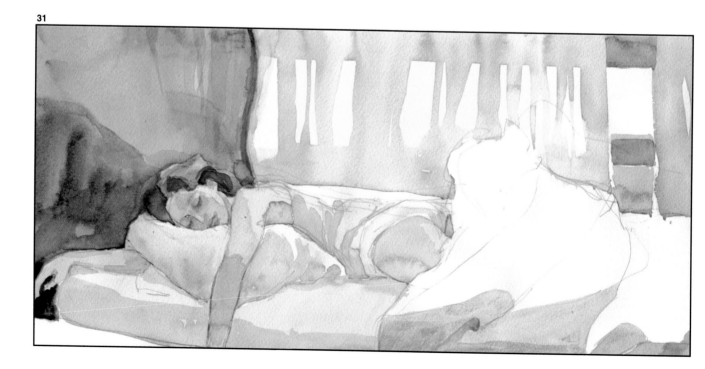

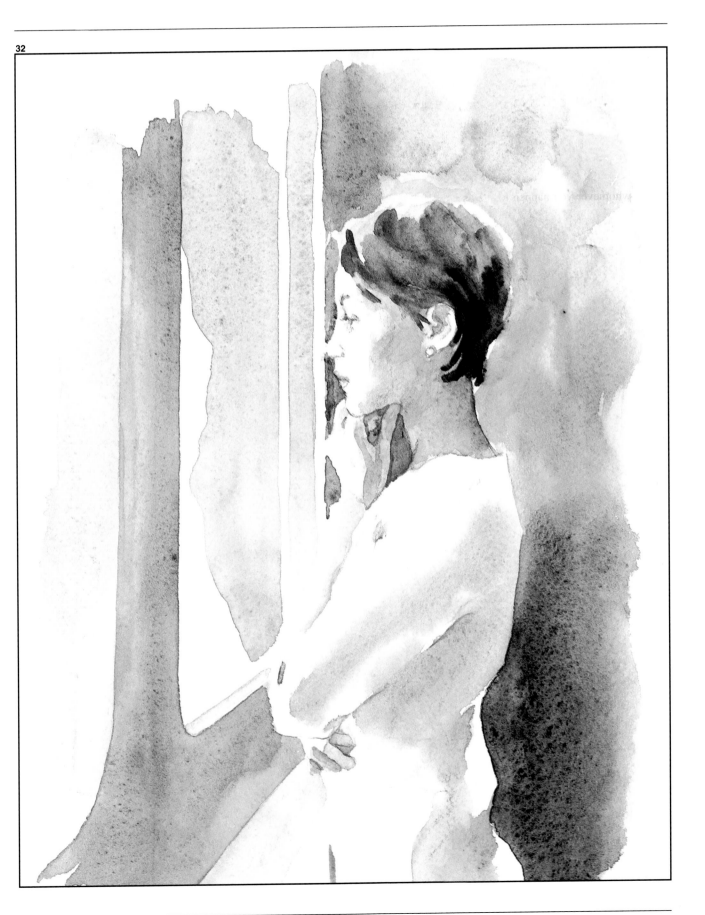

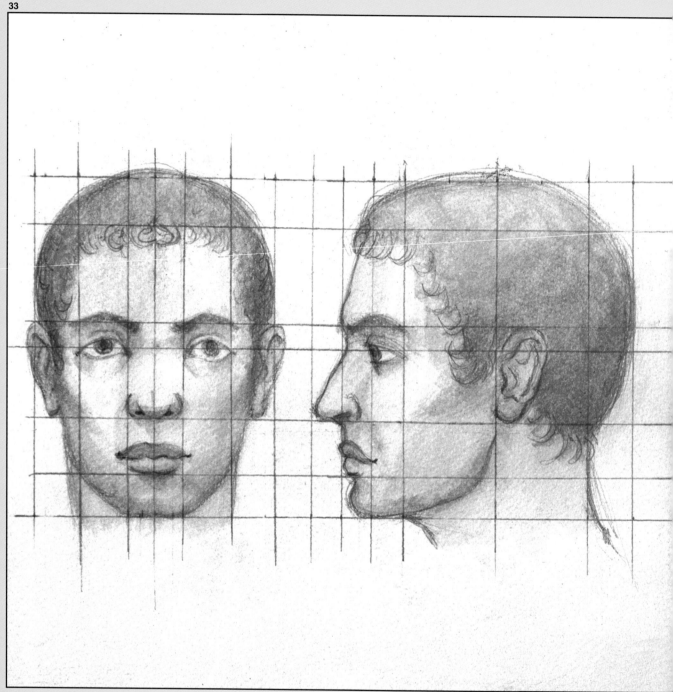

Fig. 33. The rules of proportion for the human head are as helpful to the artist as are the rules for drawing the human figure. Working with a grid such as the one shown above ensures the correct placement of facial features in relation to one another.

PAINTING CORRECT FACIAL PROPORTIONS

As you've seen, in order to draw and paint the human figure, artists of classical antiquity made calculations to establish standardise measurements we call rules of proportion. The same is true if we want to draw or paint well-proportioned facial portraits. The rules of proportion for the head are based on measurements or units that determine the location of the hairline, eyebrows, eyes, bottom of the nose, and lips, as well as the shape of the chin. In the following pages, we'll review the "fortuitous coincidences" found in the rules of proportion as they apply to various facial features when drawing and painting portraits.

Portraying Adult Heads

Let's start by studying the rules of proportion for the adult head. The rules for the head, like those for the figure, are made up of measurements or units, which are basically the same for female and male portraits (fig. 35).

To draw a diagram that follows the rules of proportion for the head, using a pencil, ruler, and T-square, draw a rectangle measuring 5^1/$_2$ x 3^7/$_8$" (14 x 10 cm). This rectangle corresponds to the ideal proportions of the human head. Next, draw a cross inside the rectangle to divide it into four equal parts. Line A gives us the axis of symmetry. Line B marks the height of the eyes, since the eyes are exactly in the centre of the head. But the basic unit we'll be working with is the height of the forehead. The total height of the ideal human head is three and a half times that of the forehead, so we ignore line B for the moment and divide the height of the head into three and a half units (the half unit corresponds to the hair). In so doing, we create the following points of reference: the top of the head (C), the hairline (D), the eyebrows and top of the ears (E), the bottom of the nose (F), and the bottom of the chin (G). An additional line halfway between lines F and G marks the bottom of the lower lip.

Finally, the same unit (based on the height of the forehead) can be used to divide the width of the head into two and a half units (ignoring line A for the moment). The reference points created in this step are for the width of the nose (H, I) and for the outer points of the eyes and eyebrows (J, K). Notice also that the distance between the eyes is the same as the width of one eye.

In the head seen in profile, the procedure is similar. In profile, the head is as wide as it is high—three and a half units. We divide the width of the profiled head into three and a half units, with the half unit at the back of the head. We can then divide the unit corresponding to the face itself into three equal parts, thus locating the same facial features we marked on the frontal view.

*Fig. 34. **Portrait of a Young Lady** by William Merritt Chase (1849–1916) positions the head in a traditionally favoured position, the three-quarter view.*

Fig. 35. The rules of proportion for facial features, like those for parts of the body, are based on units of measurement. By working with letter-coded units, portraits can be painted with much more ease and accuracy.

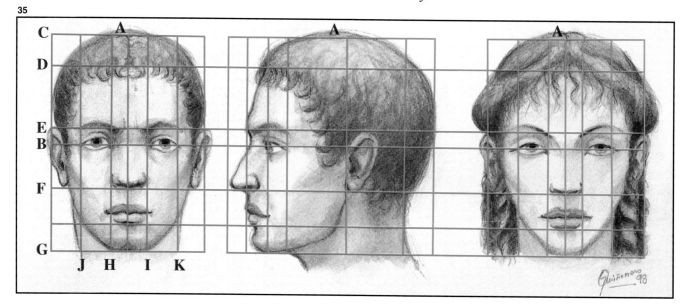

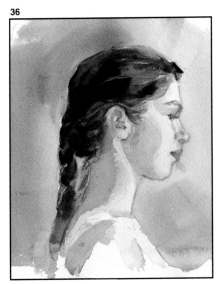

36

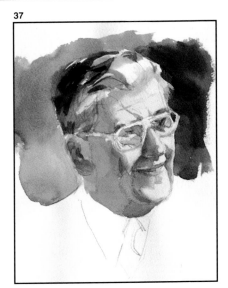

37

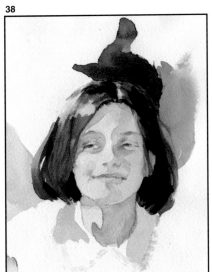

38

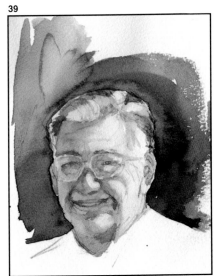

39

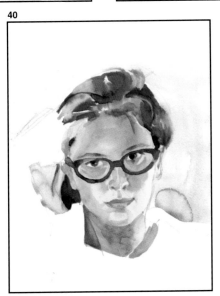

40

As shown (fig. 35, opposite), the rules of proportion for the female head are almost the same as for the male, but the face is usually a little smaller; the eyebrows are slightly more arched; the bridge of the nose is more gently rounded and narrower; the mouth is slightly smaller (though the lips may be thicker); and the jaw more rounded. In general, a woman's face is made up of softer lines and more gently curved shapes.

As you can see, the rules of proportion can be useful to you as a guide in painting portraits such as those created by Merche Gaspar, with the subjects shown in profile, frontal view, and three-quarters position (figs. 36–39). The latter pose is really no more difficult than the frontal view, since the units that determine placement of the eyebrows, eyes, nose, and mouth are the same; the only adjustment is that you have to displace everything to one side or the other of the centre line dividing the human face into symmetrical halves. Along with the frontal view, the three-quarters position is often chosen by artists for self-portraits.

Figs. 36–40. With practice, painting facial features in correct proportion will start to come to you as second nature. These evocative portraits painted by Merche Gaspar in only about fifteen minutes each show how a fine artist does it every time.

Portraying Children's Heads

The head is the part of the body that grows the least, but there are substantial differences between the heads of a boy, a teenager, and a grown man. Let's see what these differences are.

We'll start by studying the facial characteristics of the head of a two-year-old boy (fig. 41a). Notice first that the forehead is high. The distance between the eyes is greater than in a man. The ears, though proportionally larger, are located lower down. The nostrils are more visible, and the chin is much rounder and doesn't protrude as far.

In the head of a six-year-old (fig. 41b), the hairline has moved down, invading part of the forehead. The face is longer because of the development of the jaw, although the jaw continues to be rounded. The eyes, eyebrows, nose, and mouth have been displaced upward.

With the arrival of adolescence, the face at twelve (fig. 41c) looks much more like a grown man's. But the eyebrows, eyes, and ears are still low; they haven't yet arrived at the centre of the head, as the adult rules of proportion dictate. The jaw is no longer rounded, and the shape of the lower jawbone itself begins to be seen.

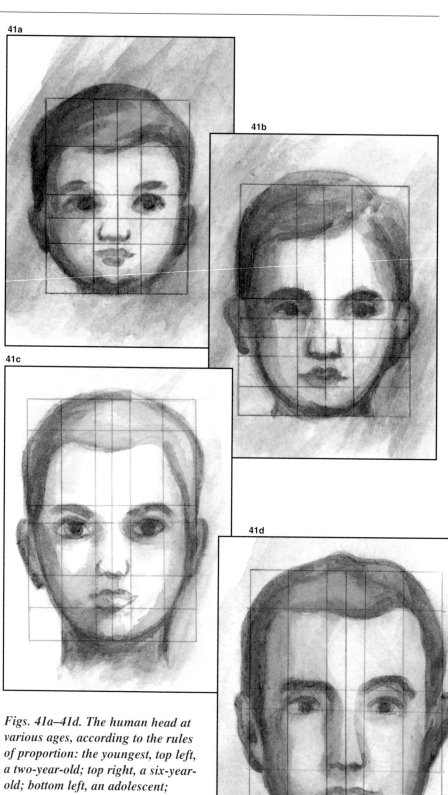

Figs. 41a–41d. The human head at various ages, according to the rules of proportion: the youngest, top left, a two-year-old; top right, a six-year-old; bottom left, an adolescent; bottom right, an adult.

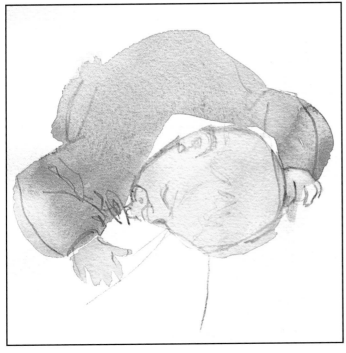

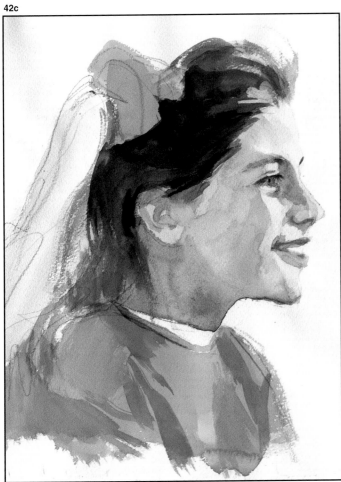

42c

Between twenty-one and twenty-five (fig. 41d, opposite), the face reaches maturity; its proportions now match those of the adult rules of proportion described earlier. Let's just take note of a few changes the head has gone through by this stage. The eyes are more oblique and have moved progressively closer to each other until the distance separating the eyes is that of an adult—that is, equal to the width of one eye. Certain facial features—nose, cheekbones, jaw—are harder and more angular than in the child, because the bone structure of the front half of the cranium has become more evident.

42b

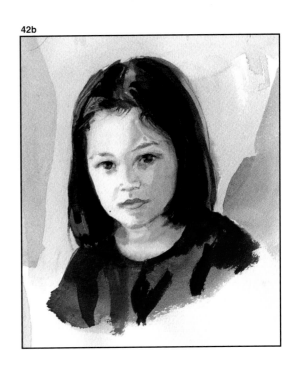

Figs. 42a–42c. The rules of proportion for the human head at different ages play an important role in the artistic quality of these portraits. Working from certain points of reference makes it easier to represent proportions correctly and achieve a closer likeness.

Positioning the Head

Now that you're familiar with the procedure for drawing the human head, we're going to put it to use. In order to carry out this exercise, you'll need to use a live model. Ask a relative or friend to pose for you for a few minutes.

The exercise consists of drawing the head of the model while he or she is sitting across from you. A sphere is the basis of the exercise. Begin by drawing a circle freehand, with a tilted axis (A) bisecting it (fig. 43a). Imagine that the circle is a sphere, and (fig. 43b) find the height of the eyes (B) on the surface of the sphere (remember that they should be exactly in the middle of the head). Find the axis of symmetry (C). Once you've marked the symmetrical centre of the face, locate the ear, mouth, chin, bottom of the nose, hairline, and eyebrows (fig. 43c). Using lines like this to guide you, you'll see that you can draw heads in different positions with relative ease. Don't be too concerned about capturing your model's likeness in this exercise.

Figs. 43a–43d. These diagrams are the basis of an exercise for painting head portraits, as described in the text on the left.

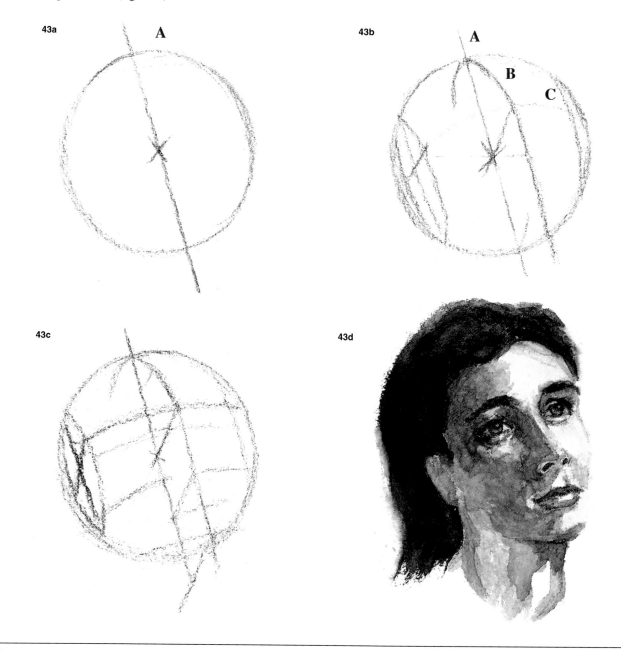

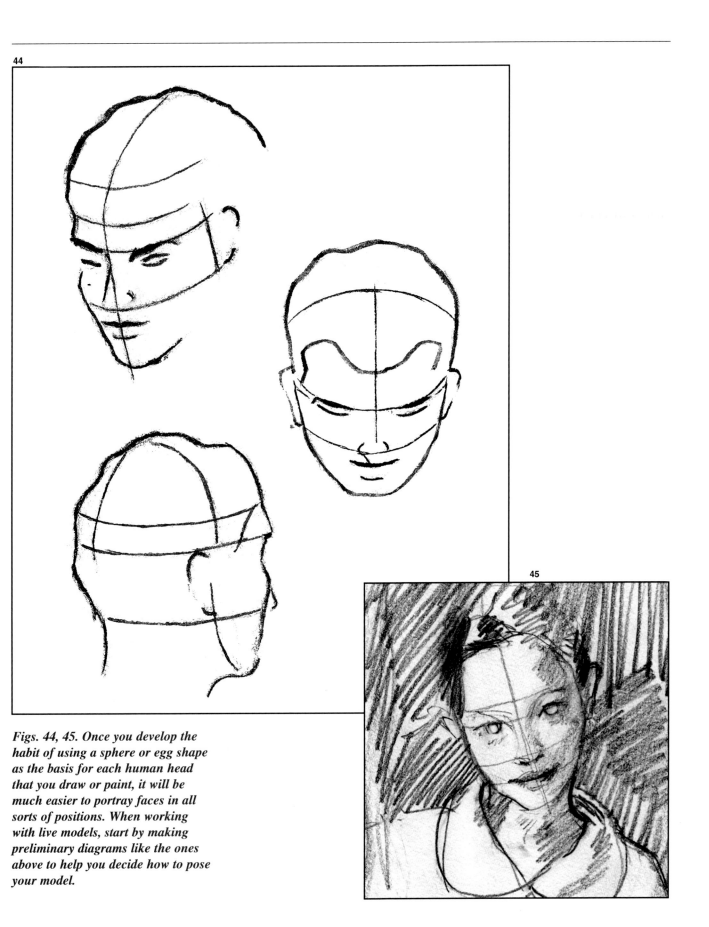

45

Figs. 44, 45. Once you develop the
habit of using a sphere or egg shape
as the basis for each human head
that you draw or paint, it will be
much easier to portray faces in all
sorts of positions. When working
with live models, start by making
preliminary diagrams like the ones
above to help you decide how to pose
your model.

Painting Self-Portraits

Now I invite you to try painting a self-portrait, following the example of my good friend Merche Gaspar, a very capable watercolourist. The great advantage of self-portraiture is that the artist's model is always patient and always available.

First, Merche hangs a mirror on the wall. She stands three or four feet away, so she can see her head and upper torso reflected in the mirror (fig. 46). Note how the artist has positioned herself so that her materials (palette, paints, water jar, brushes) are within reach on a small table to her right. She chooses a comfortable position in front of the mirror so that she can see herself easily and paint at the same time.

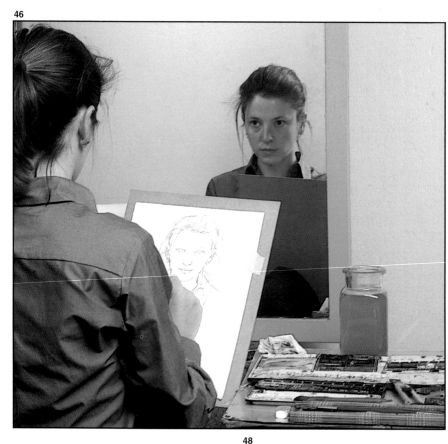

Fig. 46. Preparing to paint a self-portrait, Merche sits about four feet away from her mirror, studying her features carefully as she makes her preliminary sketch.

Fig. 47. Her drawing is now fairly detailed and has achieved a good likeness to the image in the mirror, don't you agree?

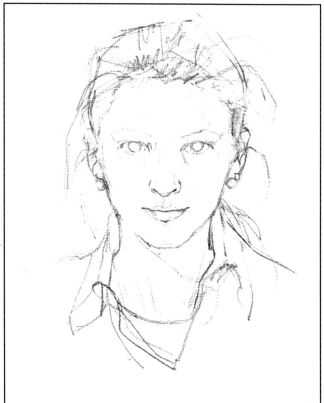

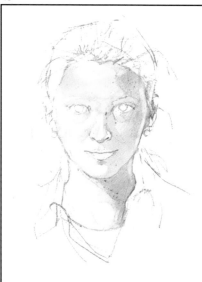

Fig. 48. With a #12 brush, the artist gives her drawing a preliminary tonal gradation, clearly differentiating lighted areas from shadowed.

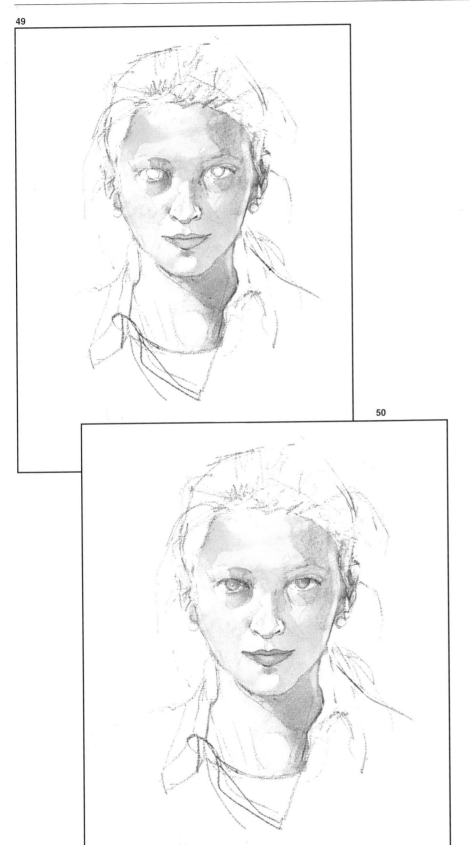

49

50

Merche starts drawing her face, first using a few schematic strokes for the shape of the head. Little by little she adds the characteristics that define her appearance, taking her time to portray each feature with precision (fig. 47, opposite).

She uses the direct method of painting, applying a first gradation of colour for her skin tone, mixing ochre, vermillion, and burnt umber. She has to work fairly quickly, so she wets the paper and then limits herself at first to defining the initial tones, that is, the lighted area and the area in shadow (fig. 48, opposite).

The artist continues by adding washes of colour, although she treats the toned areas very loosely, without getting too exact. Note that when painting a portrait of a white person, the skin is not pink, as is commonly believed, but can include a wide range of colours subtly incorporated in the skin-tone blend. A good general rule is to use cool nuances (blue, green, purple) for areas in shadow and warm colours (yellow, orange, red) for more lighted areas (fig. 49).

Once Merche has achieved a fresh, bright portrayal of her facial skin, she goes on to work on the eyes and lips, but without completely finishing them. She just applies a weak wash that she'll continually reinforce as the painting progresses (fig. 50).

Fig. 49. With the same #12 brush, she continues applying more and varied skin tones. The colours tend toward ochre where light falls brightest on the face, and violet in shadowed areas.

Fig. 50. With a fine #8 brush, Merche starts to colour the eyes and lips, applying soft tones that she'll darken as the painting progresses.

Observe the broad range of tonal values used on the skin and how the artist darkens values on the right side of the head to give it contour and volume (fig. 51). She also accentuates shadows around the features and darkens the eyebrows. Notice that each shadow has its own colour; for example, the shadow near the nose is violet, while on the cheeks it's pinkish. She uses a very diluted violet for the hair, which she'll let dry, then develop at a later stage.

Using a wide brush, Merche starts to paint the background with a very diluted violet wash (fig. 52), being careful not to get it on the face itself.

After the paper has absorbed part of the moisture from the background colour, the time has come to paint the hair with a wash made of burnt umber and what was left over from painting the background. Quickly and deftly, Merche paints the dark areas, her strokes following the natural direction of the hair (fig. 53).

51

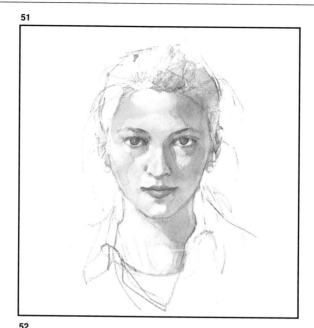

52

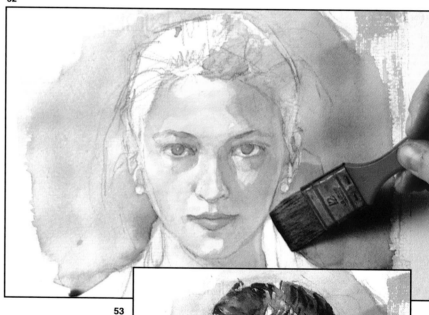

53

Fig. 51. Now a bit of pale violet wash is applied to the hair.

Fig. 52. Using a wide brush, Merche spreads the same pale violet wash over the background.

Fig. 53. She works on the hair again, finishing it by superimposing a second wash: a mixture of burnt umber with a touch of violet.

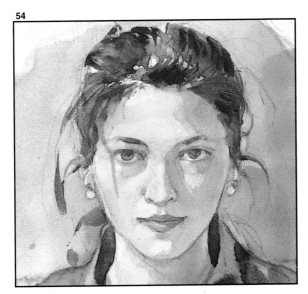

Fig. 54. Using a smaller brush, she finishes the finer details of eyes, lips, and eyebrows.

Fig. 55. Her self-portrait is now complete. Look at how Merche has achieved a remarkable likeness by using just a few tones to give freshness and softness to her features.

She makes sure the eyes show the right degree of brightness and that the upper lip is somewhat darker than the lower lip, defining the two planes that make up the mouth (fig. 54).

Now it's time to paint the shirt. Working on wet paper, she starts with a diluted paint that she gradually intensifies as she portrays the effects of light and shadow on the cloth (fig. 55).

The final painting meets two objectives of portraiture admirably: capturing facial likeness and subtle aspects of the sitter's personality.

Using Merche's techniques as your guide, now it's your turn to try painting a self-portrait.

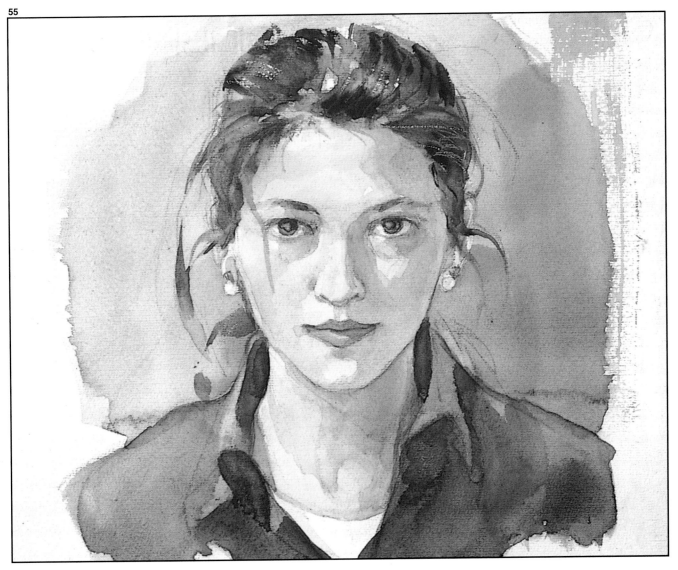

56

Fig. 56. The portrait is one of the most challenging genres and also one of the most gratifying when a good likeness is achieved. Here are two self-portraits in pencil by Merche Gaspar.

Portraiture

Now that you've learned how to establish correct proportions in drawing facial features, let's explore portrait painting further. Even if portraiture isn't of primary interest to you, when drawing the human figure, you should know how to paint expressive faces as well. This is accomplished by capturing not only the model's features but the essence of his or her personality. Other aspects of portraiture covered in this section include how to light and pose a model; how to compose and block in a portrait; how to choose the format and size of the painting; and some tips for achieving facial likeness.

Rules for Painting Good Portraits

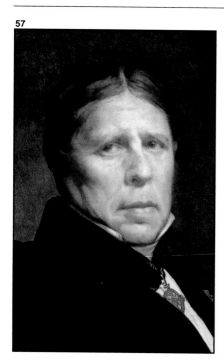

57

For many centuries artists have grappled with ways to convey the essence of a person's being in a portrait. The watercolour medium has been used in a wide range of approaches, from precisely rendered realistic portraits to wildly free and expressionistic interpretations.

The approach taken here is based on the premise that for a portrait to look like the model, the painter must follow mathematical rules for constructing the head and also know how to emphasise a feature, a facial expression, or even a pose that will best characterise and capture the subject's individuality.

A wonderful guide on our journey into portraiture is Jean-Auguste-Dominique Ingres (1780–1867). This famous French portraitist (fig. 57) set down many invaluable rules that I would like to paraphrase for you at random.

Be somewhat of a caricaturist, always looking for the dominant facial trait to emphasise or even exaggerate in your portrait paintings.

An artist can paint a good portrait only by penetrating the spirit of the model. For example, if your model is a powerful man, don't limit yourself to portraying his physical strength; try to express his forceful demeanour as well.

Notice how the sitter usually holds her head when she speaks or how your model positions his body when he sits, and build those poses into your paintings to best exemplify those models.

Before starting to sketch, talk with your model and observe his or her most characteristic facial expression to portray in your painting.

Also study the most habitual postures within age groups, and keep those generalities in mind when deciding how to pose a model.

When drawing, you must keep your eyes moving over your subject, taking in everything at once. Work all over a painting up until the very last minute, bringing about harmony from section to section as you proceed.

Develop the eyes as you go.

Paint the way you draw. Just as you use your pencil all over a composition as you sketch, distribute colour over the whole portrait as you paint.

The contrast of light and shadow is what animates a portrait.

Consider the distribution of shadows, half shadows, and light areas. Avoid excessive highlighting, which could break up the mass.

Examine details to determine what must be controlled and corrected.

Portraits of women should not be dark, but as light as possible.

Infuse balance into portrait figures; construct, search, join parts together with lines, compare large masses and brushstrokes, work towards harmony.

Observe the work of the great masters: Michelangelo above all, then Raphael. Both of them reached mastery in their art, and what road did they take to get there? Being humble, they studied other masters who preceded them.

In summary, above all, to obtain good results in the art of portraiture, you must devote hours and hours to practising, studying, and experimenting.

Although you may not be satisfied with your results at first, by following the advice given here, little by little you're bound to see improvement, and before long, your portrait drawings and paintings will reflect your subjects more accurately.

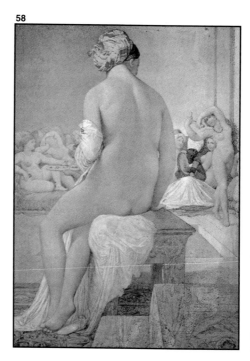

58

Fig. 57. Ingres, shown in the oil self-portrait above, offers excellent guidance on the art of portraiture.

Fig. 58. Left, Odalisque by Ingres is a good example of his stylised treatment of the human figure, painted here in watercolour.

Fig. 59. Right, Portrait of Sir John Godsalve by Hans Holbein illustrates how powerful the portrayal of eyes can be in holding the viewer's attention.

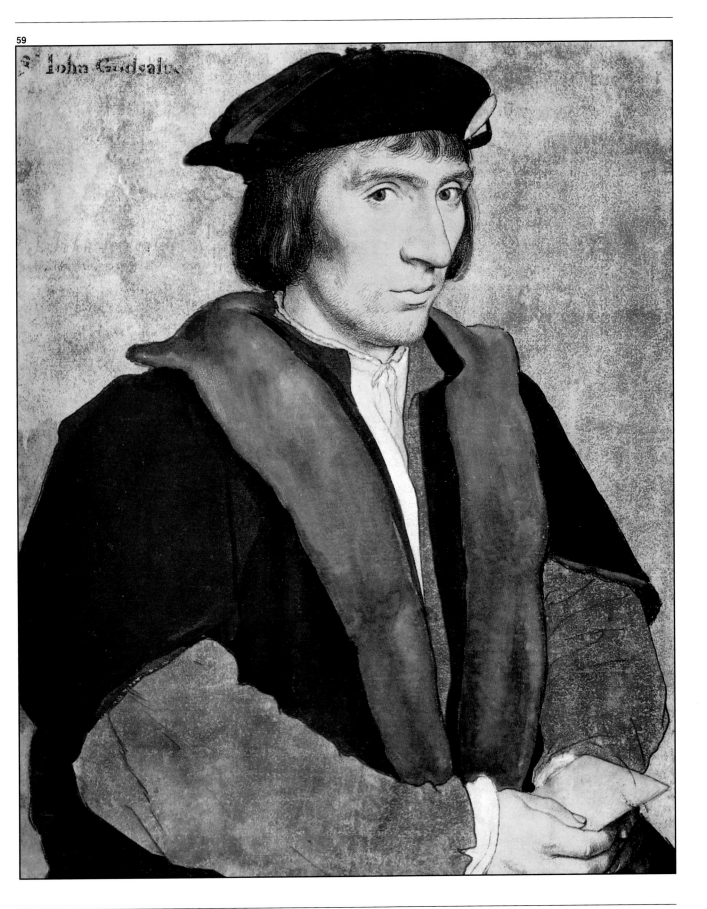

59

Io̅hn Godsalve

Lighting and Posing a Model

In this section we'll discuss the direction and quality of light to use for a portrait, how to position your model, and where to place yourself in relation to your subject.

The person sitting for a portrait may be illuminated by natural or artificial light. Many painters prefer artificial light, from a nearby 60- or 100-watt bulb. This choice allows the artist greater control by shifting the lamp to guide lights and shadows falling on the model's face. Directing the chiaroscuro in this way helps the artist to model facial planes and features. But what direction should the light come from? Let's turn again to Ingres, who said, "Light should illuminate the model almost from the front, but slightly above and off to the side of the head."

In other words, the light should be slightly raised, but much more frontal than lateral, since more light than shadow should be shown on the model's face (fig. 60). Positioning the light slightly to one side means that the other side of the model's face will be slightly in shade, with wide, soft shadows on the forehead and cheeks and somewhat more contrasting values for the eye sockets, lower part of the nose, neck, and lower lip.

As to the pose, whether your portrait is to be head only, half-body, or full-body format, the best position for your model is seated. Your eyes and the model's should be at the same level.

Be sure your model sits in a comfortable, natural position. Avoid a rigid or contrived posture that will be both uncomfortable and difficult for the model to sustain long enough to pose quietly, without having to shift around a lot. Check the position of the model's head and consider having it turned a bit to the side for a more casual, spontaneous look (fig. 61).

60

61

62a

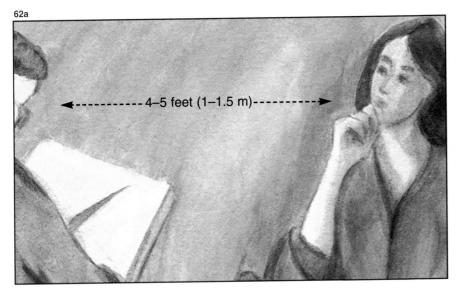

<-------- 4–5 feet (1–1.5 m) -------->

62b

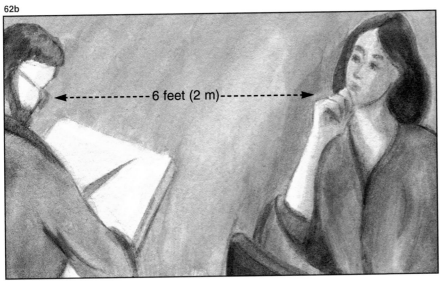

<-------- 6 feet (2 m) -------->

The model's clothing should be loose, ideally having lots of folds to catch light and shadow for you to interpret artistically. If any of the model's clothing or accessories are too distracting in a portrait—excessive pattern or trim on a dress, complicated jewelry, and so on—just simplify or eliminate it completely. If the model has an over elaborate hairdo or extremely large hands and you think you can make the portrait look better by reducing their size, do so. Don't be afraid to exercise artistic licence if you think your portrait will be improved by doing so.

Always keep in mind the distance between you and your model. For a head portrait, the distance should be four or five feet (fig. 62a); for a half-body composition, about six feet (fig. 62b). For a full-body portrait (fig. 63), the required distance is much greater: between nine and fifteen feet.

63

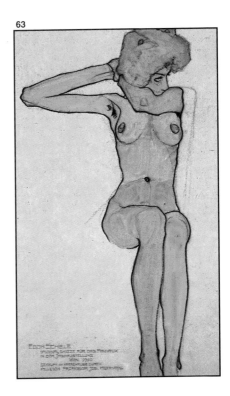

Fig. 60. Opposite, left, a self-portrait by John Singer Sargent is lit both frontally and from the side.

Fig. 61. Opposite, right, in Winslow Homer's **Woman Sewing,** *the light source is off to the side and slightly elevated.*

Figs. 62a, 62b. Above, for the portrait of a human head, the distance between the artist and the model should be four to five feet; for a half-body portrait, about six feet.

Fig. 63. For a full-body portrait such as Egon Schiele's **Nude,** *the distance between the artist and the model should be nine feet or more.*

Composition and Sketching

Once you've established your working position at a correct distance from your model, you're ready to deal with the question of composition: structuring the scene with the right proportion of space surrounding the model and where to position the model within the setting (fig. 64).

We'll start by deciding on the position of the model's head, which can be drawn looking straight at us, in three-quarters position, or in profile (although the latter pose is not used often). If you paint the model frontally (fig. 65a), the head should be located in the centre of the painting. If you paint the head in three-quarters position (fig. 65b), place it slightly off-centre, with more space in front of the model's face than behind it. Finally, for a profile portrait (fig. 65c), the head should shift well over to one side of your layout, with much more space in front of the head than behind it. To paraphrase Ingres again: Leave more space in front of than behind a head, to give it ample breathing room.

I advise you to choose a frontal or three-quarters position, the most common for portraiture. It's usually preferable to orientate the body in a different direction from the head, so have the model raise, lower, or tilt the head slightly to the side for a more natural, "unposed" look.

Once you've taken these general considerations into account, make four or five small pencil sketches (figs. 66a–67), trying to improve on each by blocking in basic shapes, working on proportions, and establishing the best pose for the model. Consider changing the position of the arms, the direction the model is looking in, or the general tilt of the body. These compositional variations will help you decide on the final pose.

64

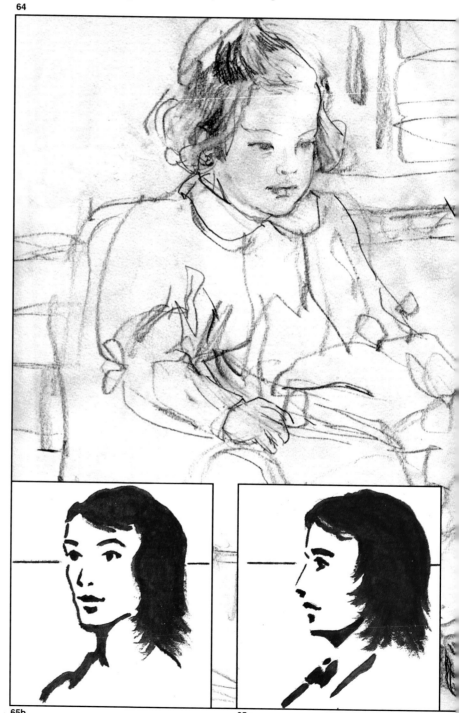

65a

65b

65c

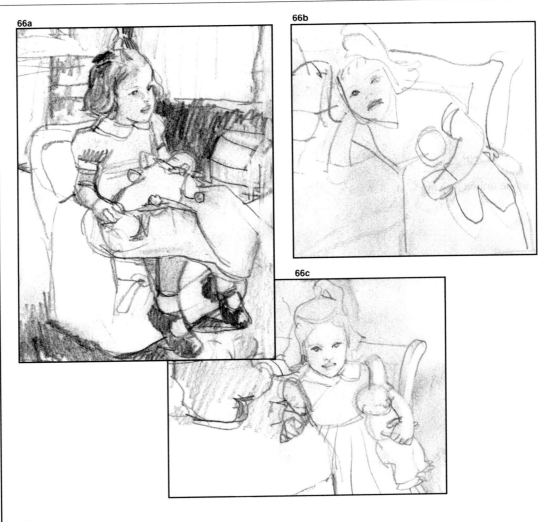

66a

66b

66c

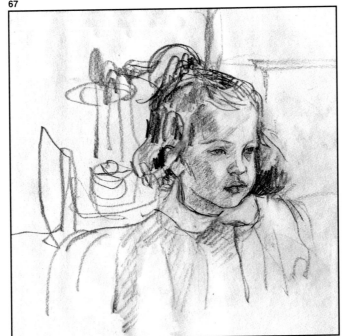

67

Fig. 64. Opposite page, top: Here are Merche's preliminary sketches of the same subject.

Figs. 65a–65c. Opposite page, bottom. When a head is portrayed frontally, it should be centred (65a); a three-quarter pose should be off-centre (fig. 65b); a profile should be even farther off-centre (fig. 65c).

Figs. 66a–66c, 67. Merche's trial sketches of her child model show various positions captured quickly in pencil as the little girl moved around. After sketching a model in several positions, the artist may then choose the best one to develop into a watercolour portrait.

Format and Size

As these illustrations show (figs. 68–72), the rectangular, vertical format is the one generally chosen by professional artists for portraiture, although there are some exceptions to this rule.

In the vertical format, the viewer's gaze tends to move over the painted surface from top to bottom. A vertical format usually doesn't invite the viewer very far into the scene; the depth of the painting is shallow, with a background that tends to have a limited value scale, often painted monochromatically. By minimising background and depth, the focal point is directly on the figure or head, which is why most great portraitists, past and present, work in a vertical format.

For obvious reasons, artists rarely paint life-size portraits, but there are certain standard measurements for the genre. For head or half-body portraits, a 20 x 16" (51 x 41 cm) sheet is a usual choice; for a full-body portrait, a good size is 30 x 22" (77 x 56 cm). Of course these guidelines are flexible; you may prefer, as many artists do, other formats and measurements.

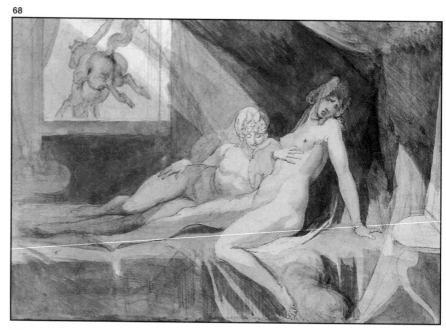

68

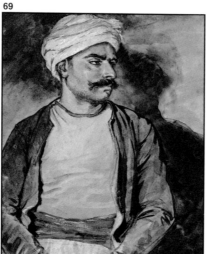

69

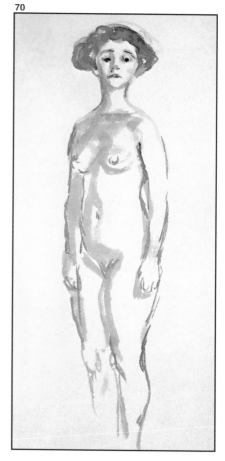

70

71

Fig. 68. A horizontal format in this watercolour by Johann Heinrich Fuseli allows the artist to put figures on a background that shows depth.

Fig. 69. Théodore Géricault's **Portrait of Mustafá** *typifies the vertical format for half-figure compositions.*

Fig. 70. In a figure painting like Edvard Munch's **Blue Nude,** *the narrow vertical format would make the inclusion of a well-defined background difficult.*

Fig. 71. A textured wash or range of tonal values are ways to create an illusion of depth, as shown in this watercolour by Ester Llaudet.

Fig. 72. Opposite, in Pierre Bonnard's **Nude,** *we can see how a wide vertical format allows the inclusion of background detail.*

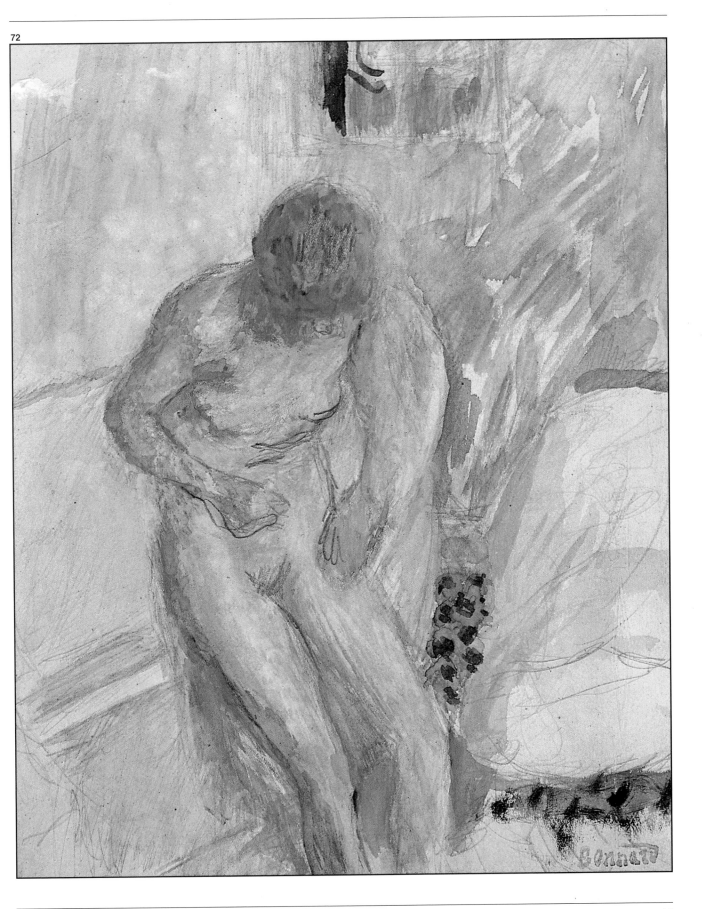

The Preliminary Drawing

A good drawing is the indispensable starting point for any good portrait. Professional painters always begin by sketching. In fact, the success of their portraits can be attributed in large measure to preliminary drawings, such as those shown on this and the opposite page (figs. 73–77).

So the first thing that all watercolourists should concentrate on in preparation for success in painting portraits is drawing. Don't be put off, as many beginners are, by thinking that portraiture requires an innate talent at capturing likeness. A simple but evocative portrait drawing doesn't require special ability at portraying likeness. If you're willing to learn, to persevere, to practise, you'll develop a keener eye for observing facial features, and a more experienced hand at setting down what you see. With practice, a facility for drawing and painting closer resemblance to your models will follow.

So draw, draw, draw. Ask relatives to pose; do self-portraits in front of a mirror again and again; work with photos of friends; sketch groups of people in the street; and so on.

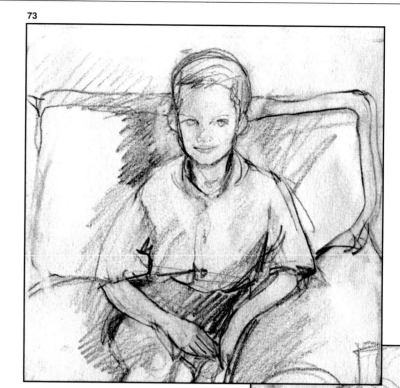

Figs. 73–76. Merche Gaspar practises continually, drawing from live models in preparation for her watercolour portraits. I strongly urge that you do the same, for the secret of a good painting lies largely in good drawing.

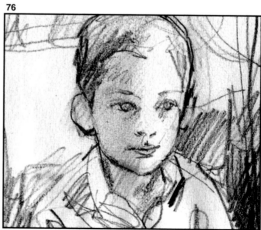

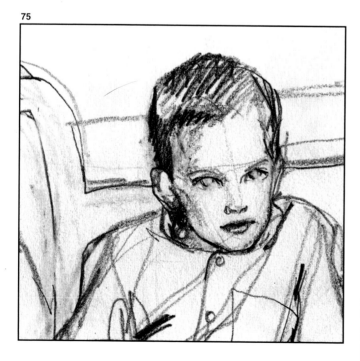

Whenever you draw portraits, keep the basics that we've reviewed in mind: lighting and posing the model; calculating proportions; positioning the model and yourself in correct relationship; planning the pattern of empty space surrounding the model. Practise with and analyse the problems of format, composition, proportions, and look for solutions to the potential challenges posed by the portraits you've chosen to paint.

And above all, to develop as a portraitist, try to draw daily, as professionals do, as preparation for creating better and better watercolour portraits.

Fig. 77. This nearly square format is a good choice for a seated figure positioned on an angle. By cropping the figure as Merche has, attention is directed to the boy's head and torso.

77

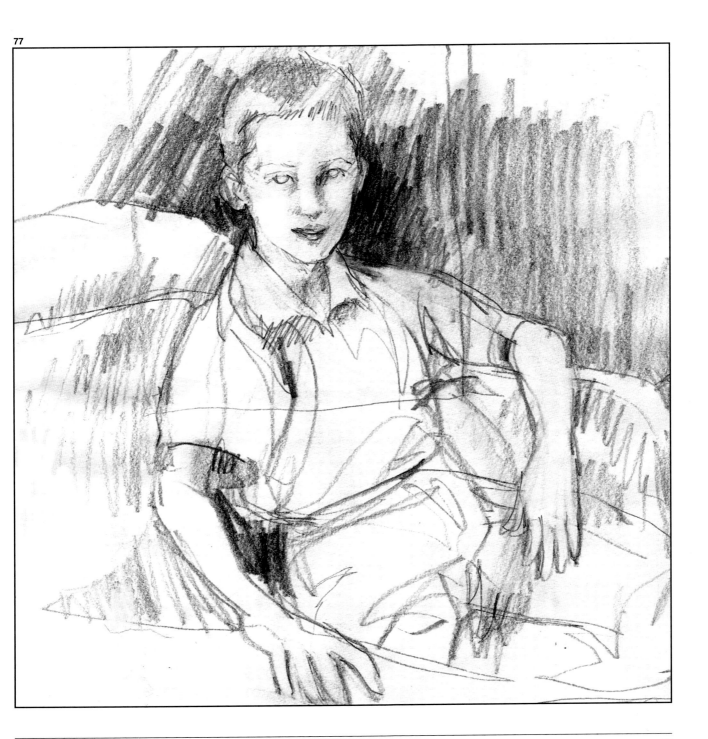

STEP-BY-STEP EXERCISES

On the following pages, you'll find a series of practical exercises in which to apply what you've learned from the first part of the book. Several of the exercises in this volume are accompanied by numbered sheets of drawing and watercolour paper with patterns printed on them to assist you in following the steps and instructions. These exercises will help you develop skills needed for painting the human figure and face in watercolours. Your success lies in putting these exercises into practice. The more hours you devote to learning, the more your skill and mastery of the genre will grow.

Proportioning the Male Figure

To put the theories you've learned into practice, begin by portraying a frontal view of a male nude. For this demonstration we rely on the invaluable guidance of Ester Llaudet, an excellent watercolourist and art teacher whose illustrations enliven the next several pages.

Using the rule of proportion that establishes a figure equivalent to eight heads high, Ester takes a ruler, T-square, and pencil and draws a rectangle measuring $6^{1}/4$ x $1^{1}/2$" (16 x 4 cm), then divides it into eight units of $1^{1}/2$ x $^{3}/4$" (4 x 2 cm) each. Now she rules a line down the centre, dividing the rectangle in half with an axis that will guide the symmetrical construction of the human body. You'll find this grid, marked with the letter A, on pattern number 1.

Using the grid, start to sketch the figure, as Ester has done in her first sketch (fig. 78), following these guidelines:

The first unit marks the height of the head.

The second takes in the neck, shoulders, and part of the chest.

The third begins at the nipples and ends slightly above the navel, at the elbows.

The fourth ends at the wrists and pubic area.

The fifth ends at mid-thigh

The sixth ends at the knees.

The seventh ends at mid-calf.

The eighth (slightly longer) unit completes the figure at the toes.

Once a preliminary sketch is completed, the most difficult part is over. Now Ester uses her watercolours and a #8 brush, and starts to apply colour (figs. 79, 80). Achieving the right gradation of colour to simulate skin tone can be tricky. We may think of human skin as being an even tone, but look again, and you'll see that contours, joints, and musculature create plays of light and dark values across the skin surface, producing a shifting range of tonal values all over the body. It's important to identify these anatomical contours and know how to portray them, just the way Ester does.

78

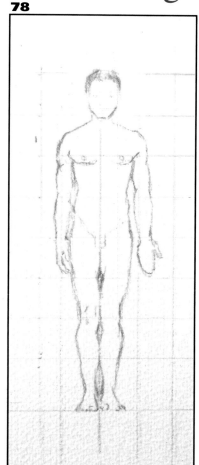

79

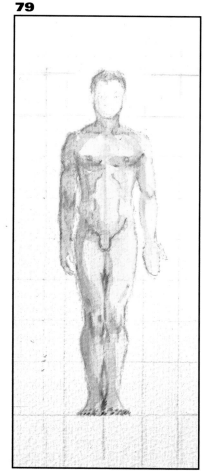

80

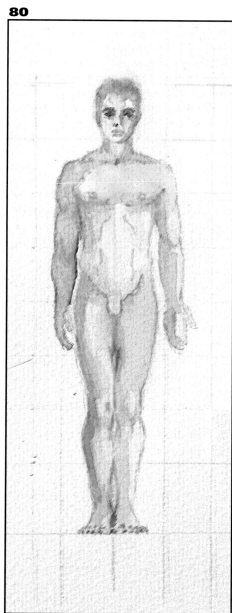

Figs. 78–80. This series of watercolour sketches is based on the rules of proportion for the male figure, which is eight units tall.

81

Referring again to the illustrations on the previous page, let's go back over and discuss how Ester began the washes shown there.

To break up the paper's white space, first she applied a very diluted, uniform wash of burnt sienna with a touch of alizarin crimson. While the wash was still wet, she filled the brush more heavily with colour and painted a second, somewhat darker wash on areas where body contours are clearly distinguished: along the collar bone, pectoral muscles, groin, and knees. The artist continued to work on shading and gradations, discovering a whole series of different values and skin tones.

After moulding body contours further, Ester now completes her painting by developing the facial features and head (fig. 81), using the same monochromatic palette but somewhat intensified to portray dark eyes and hair.

Fig. 81. Notice that the lines dividing the units match up with some of the parts of the body.

TIPS

Base your figure paintings on the eight-unit formula.

If you have a problem with intermediate tones, combine them into fewer variations.

Use warm colours for lighter areas and add a little ultramarine blue to colours used for shadows.

Proportioning the Female Figure

The first step in this exercise illustrated by Ester Llaudet is the same as in the previous one: drawing a grid divided into eight units. (But note that the bottom unit is equal to all the others, whereas that unit was a bit longer in the drawing of the male figure.) The outer contours of a female nude are sketched in (fig. 82). Use the following guidelines to establish precision even at this earliest stage.

The first unit marks the height of the head.

The second unit takes in the neck, shoulders, and the upper chest. Note that the female's shoulders are narrower than the male's.

The third unit takes in the breasts and ends at the wasitline.

The fourth unit extends from the waist to the bottom of the pubic area.

The fifth unit ends at mid-thigh.

The sixth unit ends at the knees.

The seventh unit ends below mid-calf.

The eighth unit completes the figure at the toes.

Draw and paint female figures with softer and more sensual lines (figs. 83, 84) than male figures to reflect the more rounded contours, as opposed to the sharper, muscular angles of the male body.

Figs. 82–84. Using the rules of proportion for a female figure, remember that on average, it's a little shorter than the male figure.

82

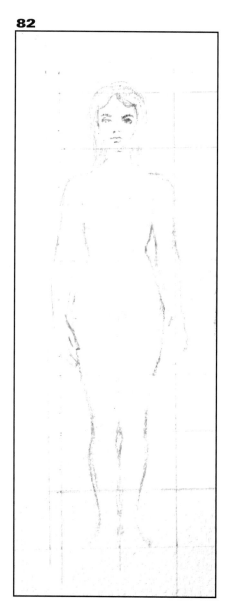

83

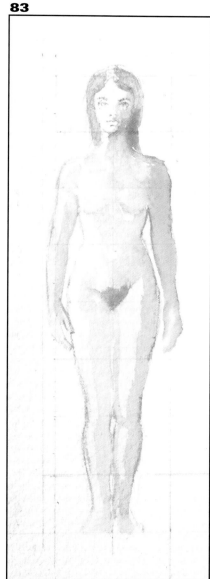

84

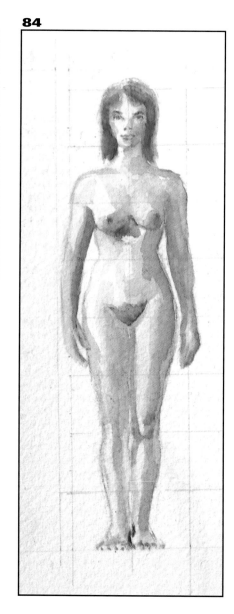

85

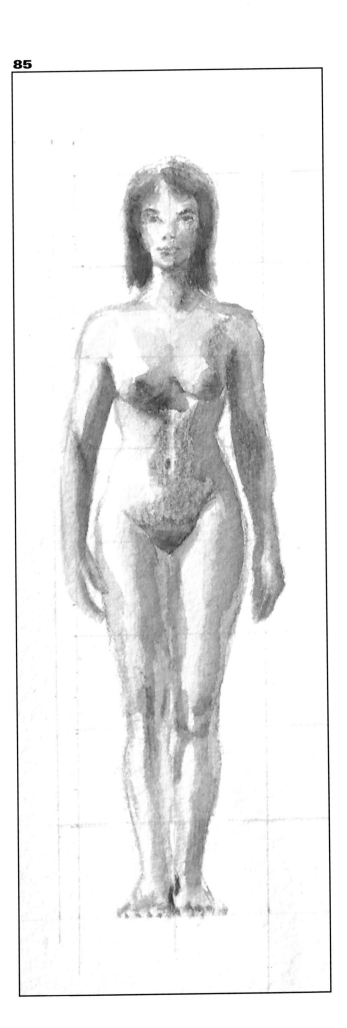

Let's go back to the previous page illustrations and refer to the first washes that Ester applied (fig. 83). She started with a translucent wash of raw sienna with a touch of alizarin crimson and ultramarine blue. Without waiting for that glaze to dry, she applied a second one to indicate from the start those areas that are lighted and those that will remain in shadow. This application introduces various tonal values so that where there is shadow, the colour of the skin will be darker, and where there is light, it will be lighter, thereby expressing basic shapes, gradation in tone, and contrasts through successive washes (fig. 84). Remember that you have to build up tones; once the paint is on paper, it's pretty much there to stay.

In the last stage, tonal gradations and modeling of contours are finalised (fig. 85). In the finished painting, observe how the skin tones have been enriched to produce a less structural and more pictorial appearance.

I hope you'll do this exercise more than once, which will be the best way to perfect your skills at painting the human figure.

Fig. 85. While shoulders on the female are narrower than on the male, hips are wider.

TIPS

The female's hips are wider than the male's, but the waist is narrower.

Male calves are usually fuller than the female's.

Musculature is generally more pronounced on male bodies.

Proportioning the Head

Ginés Quiñonero, who has studied fine arts and excels at figure painting, lends us his expertise in demonstrating how to draw a well-proportioned head. For this exercise, use the grid marked with the letter B on pattern number 1 (the same sheet used for your earlier exercise).

Ginés sits comfortably on the sofa of his studio when he draws. Find yourself an equally relaxed position and begin as he does, working with the grid. You'll recall seeing this grid earlier (pages 26–27) where the rules of proportion for the human head were first presented. These rules are the starting point for drawing a frontal view of the head.

To represent the human head realistically, with all facial features in correct proportion, the artist pencils in the eyes, nose, and mouth at specific points on the grid (fig. 86). By following his example, even your preliminary drawing will quickly tell you that you're on the right track.

As our demonstration proceeds with colour (fig. 87), apply a pale wash of ochre and a touch of cadmium red on your drawing, using a #12 brush, and without rubbing out your preliminary pencil sketch. Paint the hair with the same wash, but add more ochre to it (fig. 88).

86

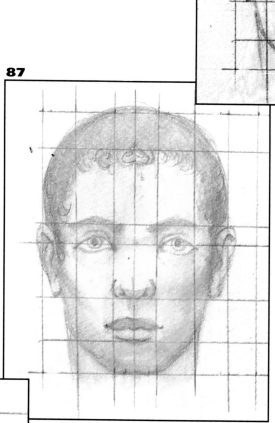

87

88

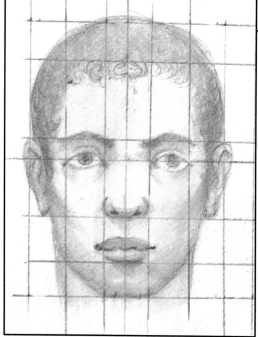

Fig. 86. The first step is a pencil drawing of the head, based on established units of measurement and the position of facial features.

Fig. 87. Once the preliminary drawing is finished, some of the white space on the paper is covered with translucent washes.

Fig. 88. The artist then works on shading, using different tones to create an illusion of volume.

Fig. 89 (opposite). The final version looks something like classical Greek art.

With careful, slow brushwork, the artist layers on translucent washes to accentuate areas of the forehead, nose, cheeks, eye sockets, and jaw, contouring the face and playing up the effects of light on it. The washes he uses are very diluted, enabling him to create very subtly nuanced tonal gradations, without imposing any abrupt changes between values. Follow his example by working with thin washes only. Thick paint will cause you to lose control of the whole process.

Now Ginés adds a little carmine to the wash and gives colour to the lips and eye sockets (fig. 89). He continues retouching and shaping the face through successive washes, adding colour to the overall tone and reinforcing details in the eyes, nostrils, lips, chin, and hair. You should be doing the same at this stage, adjusting tones and shades through step-by-step modeling until you complete your portrait.

Repeating this exercise will reinforce your skill at portraiture. The exercise can certainly be considered a very reliable guide in painting portraits from life, from photos, or from your imagination.

TIPS

The human face is symmetrical; the left and right sides are balanced. But features is what helps to make a portrait realistic.

89

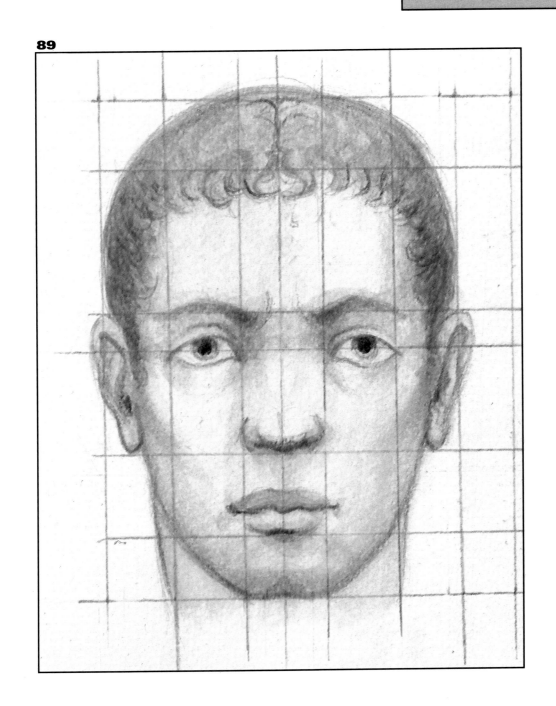

Drawing and Painting the Human Head

With her sister as her model, Merche Gaspar, both a student of fine arts and a teacher of drawing and painting, leads this demonstration, showing how to draw the human head in various positions. As the artist does, you might complete this useful exercise on one large sheet of cold-pressed watercolour paper.

Merche begins by drawing five oval frames. She sketches a frontal portrait first (fig. 90), indicating facial features lightly. As you follow her example, keep in mind the rules of proportion discussed earlier.

Her second sketch, with the model's chin raised and her eyes closed (fig. 91), elongates the neck. With the model's head slightly lowered (fig. 92), notice how the top of the head is now more in view.

A three-quarter view (fig. 93) with eyes looking front, is one of the most popular poses for head portraits. An interesting variation of it (fig. 94) tilts the head slightly and directs the eyes downward.

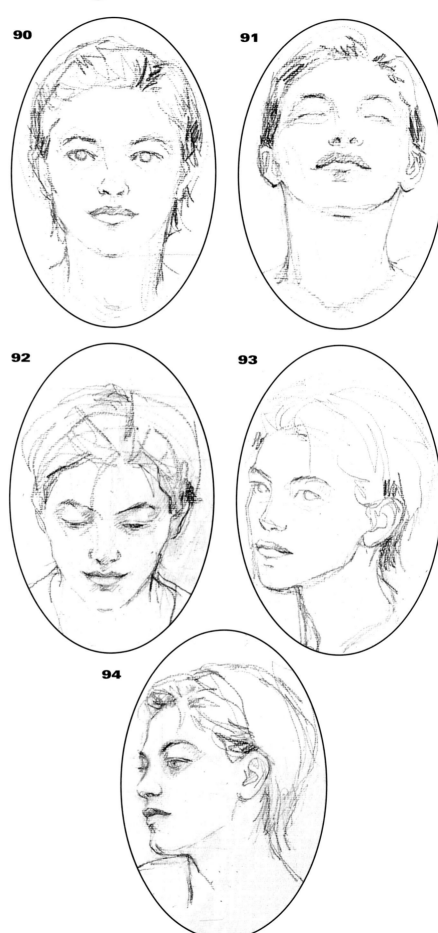

Figs. 90–94. By practising drawing the head in different positions, you can learn to deal with foreshortening, which occurs when the head is viewed from above, below, or from other oblique angles.

96

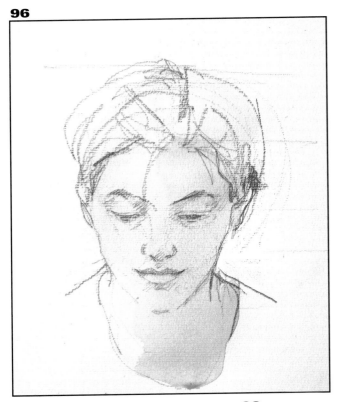

95

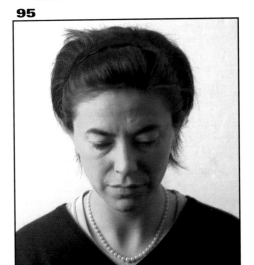

Using a #8 brush, Merche applies colour to one of her sketches, covering the face with a very pale wash of sepia and ochre (fig. 96). Let the model's photograph (fig. 95) serve as your guide in determining how light and shadow fall on the face.

Once moisture from the wash has sunk into the paper, the artist applies a second wash to darken the shadowed part of the face (fig. 97), adding more contrast and intensity to the chiaroscuro effect being created.

After the paper has absorbed part of the wash, Merche works on the hair, using loose brushstrokes and opening white spaces for highlights by scratching the paper surface with a fingernail (fig. 98). A utility knife or brush handle can also do that job.

The artist completes her evocative portrait in just five minutes. Her final step is devoted to details: painting hair falling on the forehead; colouring the lips and eyebrows; and intensifying shadows on the eyelids, nose, and neck.

97

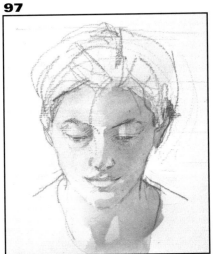

98

99

Fig. 95. In finding a good model, the best choice is often a close relative—in this case, the artist's sister.

Fig. 96. A line drawing is covered with a pale wash that doesn't obscure it.

Fig. 97. Areas of light and shadow are further defined.

Fig. 98. Facial features and intermediate tones are painted.

Fig. 99. Lighter in values than the reference photo, Merche's portrait has an appealingly fresh quality.

Musculature Study for Figure Painting

Our expert in anatomy drawing, Ginés Quiñonero, helps out once again by presenting studies designed to give you a better understanding of musculature and how to portray it in painting the human form.

Depicting muscles of the body in a painting is a subtle skill that requires practice, as all students who have had classical training in figure art know. Our point of reference for this exercise is *Écorché*, the famous sculpture by Houdon shown earlier (see pages 18–19).

Begin as Ginés does by sketching a frontal view of the figure, making very faint strokes with a #2 pencil (fig. 100). The second sketch shows a dorsal view of the model (fig. 101). Observe the shape and volume of each muscle carefully as you draw.

Working on the frontal figure first, the artist brushes on a diluted wash of sepia and a dab of yellow ochre (fig. 102), allowing a lot of the figure to remain white. Before this wash dries fully, he adds a second, somewhat darker tone to accentuate thigh and calf muscles, the soft contours of the hips and pelvis, and also areas of the upper torso.

Painting the dorsal view (fig. 103), Ginés defines musculature in the legs, the contours of the buttocks, the upper back and arms, and the back of the head (fig. 103).

100

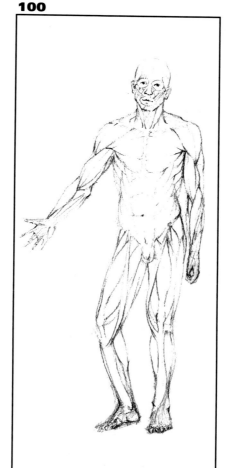

101

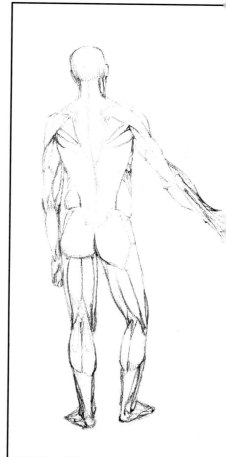

102

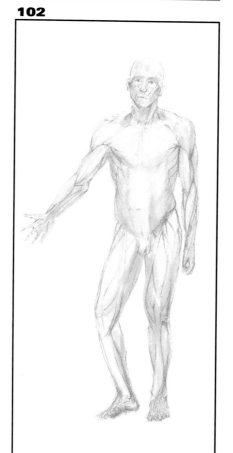

103

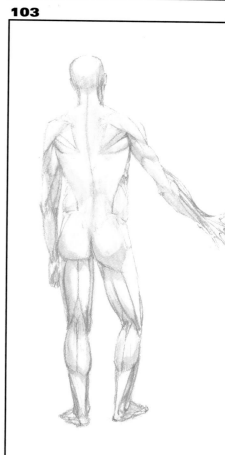

Figs. 100, 101. The artist draws frontal and dorsal views of the model.

Figs. 102, 103. After applying a first wash, he adds a darker colour to accentuate important contours.

104

105

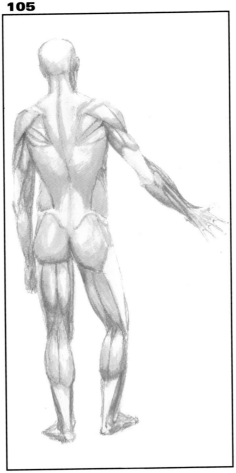

Returning to the figure shown frontally (fig. 104), now the artist defines muscle masses with greater precision, using a somewhat darker wash so that it's easier to distinguish each grouping. He strives for precision in describing musculature in the face, extremities, and torso, paying particular attention to the ends of muscles, where they attach to bones by one or more tendons.

Work on the dorsal figure (fig. 105) follows the steps taken with the frontal view. Note that tendons remain in a very light wash or the white of the paper. Since muscles are made up of fibrous membranes, a fine brush is needed to detail fibres, thus making muscles look firm and accentuating their volume.

The last step is to go over the more prominent muscles. Then the artist outlines both figures by using brown and orange watercolour pencils (figs. 106, 107).

106

107

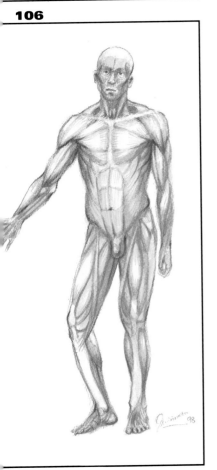

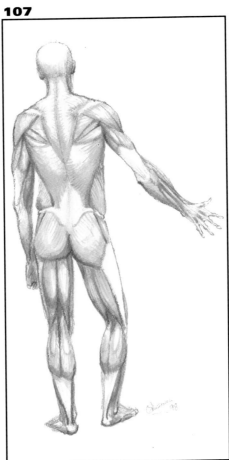

Figs. 104, 105. He defines the musculature further, using darker tonal values.

Figs. 106, 107. Once the most prominent muscles are clearly delineated, the paintings are completed.

TIPS

As with other aspects of the human form, symmetry is found in musculature. The muscles drawn on the left side of the back, for example, should be mirrored on the right side of the back.

In painting the fibrous covering of muscles, brushstrokes should generally go in a downward direction.

Light and Shadow on the Human Figure

By controlling the direction and intensity of light falling on a figure, the artist can emphasise mass rather than lines and create a painting rich in chiaroscuro—dark and light contrasts. Two examples of this premise are illustrated in the next few pages.

The first model, a clothed female (fig. 108), is lit from the side, thus presenting strong chiaroscuro effects to be captured with paint. Notice too how the model's relaxed pose orientates the body and head.

For this exercise we'll be helped by Pere Llobera, an experienced portrait artist and art teacher. As always, before starting to paint, he sketches in a faint outline of the model (fig. 109).

Using a pale mixture of raw umber and a little Payne's grey, Pere paints the face, lighting up one side by leaving it almost untouched by paint, and bathing the other side in shadow (fig. 110). He puts a pale wash on the hands and legs, then uses a mixture of sienna and a little India ink for the hair.

With a mixture of emerald green and raw umber applied to the background (fig. 111), the artist begins to paint the sweater in a rich black watercolour wash intensified with India ink.

108

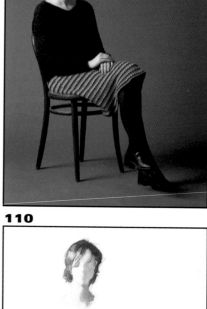

Fig. 108. Strong contrasts of light and shadow on the model's face, as shown in the photo, are an excellent basis for a portrait painting.

Figs. 109, 110. On a light pencil drawing, colour is added to the skin, hair, and background.

109

110

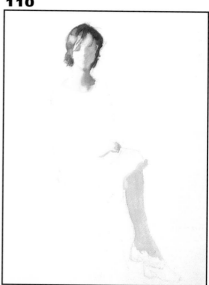

111

Figs. 111, 112. India ink added to a dark wash is applied to the sweater. Translucent tones in certain areas simulate the effects of the light.

Fig. 113. Pere paints the skirt and chair, completing the chromatic range of the portrait.

112

113

TIPS

Knowing a person well makes it easier to achieve likeness in a portrait, so try to get close relatives and friends to pose for you.

Avoid painting too many excessively flat shapes. Even the model's black shirt shown in shadow should have some tonal contrasts to give it contour and volume.

Fig. 114. Test mixtures before applying them to your painting. Tests should be on the same kind of paper that you're painting on, because watercolours can appear very different from one paper surface to the next.

Fig. 115. Learning how to paint small details, such as the pattern on this skirt, is just as important as knowing how to fill large areas with colour.

Fig. 116. To pull a painting forward visually, leave its background a bit unfinished, as in this completed portrait.

114

115

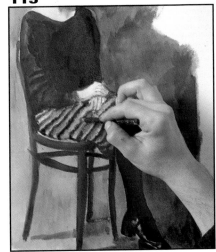

116

As he continues to develop the blouse (fig. 112), Pere works on the sleeve's folds and highlights, again using black ink, but in a more diluted form.

When he paints the legs and feet (fig. 113, opposite), he leaves white highlights on the model's shoes to simulate a patent-leather finish, then he continues to spread background colour until the subject is surrounded by it. For the skirt, he lays down a yellow wash, and when it's almost dry, superimposes on it alternating red and brown lines. For the legs and back of the chair, a blend of umber, cadmium red, and a little India ink are used. Following Pere's example (fig. 114), use test paper to try out colours before applying them to a painting.

Without waiting for the skirt to dry, the artist uses a brown watercolour pencil to accentuate some pattern details (fig. 115).

Pere continues to refine the portrait, using brushes of different sizes: #2 for details on the face, where he works to perfect resemblance; and #4 and #6 for other areas. The last step is accentuating light falling on the face by darkening the background on the side opposite the light source.

Part two of Merche's figure exercise focuses on the effects of overhead light on a nude figure. This source of light is generally from a somewhat elevated window. If artificial light is used, it is placed above the model's head. Such light produces a drawing or painting that has subtle, short shadows that almost disappear entirely on parts of the model's body.

In this case, the model poses in profile (fig. 117), wearing only a white turban. She holds a red apple, which will provide a nice accentuation in an otherwise muted painting.

As in the previous exercise, first the model is drawn in pencil (fig. 118). From the beginning, and through successive washes, Merche distinguishes the lighted areas of the figure from the subtly shadowed ones. For this first wash, she uses a mixture of raw umber with just a little manganese blue for the slightly darker skin tones (fig. 119).

A very diluted ultramarine blue is used for the turban folds (fig. 120). To create variations of skin tone, Merche works in three or four values, using a cool bluish tone to express shadowed areas and accentuate the soft contours of the model's body. She also begins

describing the lips, eyes, and cheeks, keeping them very delicately defined to be consistent with the subtlety of the rest of the figure.

117

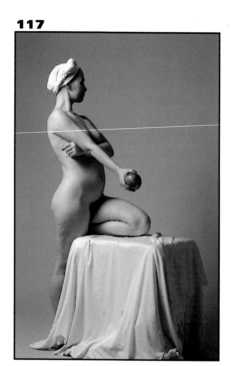

Fig. 117. With the source of light coming in from the left, the model is shown in a pose reminiscent of the bathing women painted by Ingres.

Fig. 118. Merche's inital drawing is done with a #2 pencil.

Figs. 119, 120. The first hints of colour are added to the drawing through successive washes of skin tone.

118

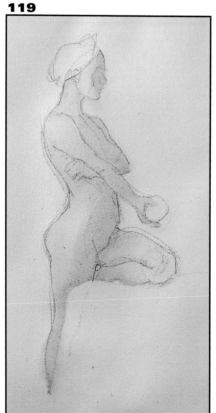

119

120

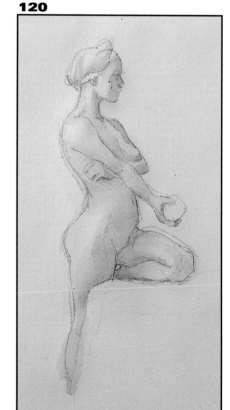

121

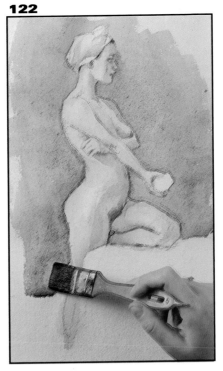

122

With a little more shadowing added in the pubic area (fig. 121), the painting is almost complete. All that remains is to finish the background and platform on which the model's leg rests, which is covered with a white cloth.

Merche uses a wide brush to apply a diluted ultramarine blue to the background (fig. 122). Observe how she holds her brush to paint well-defined edges, being careful to avoid invading the space occupied by the figure.

The artist loads her brush with a mixture of carmine and lemon yellow, providing a single, contrasting point of warm colour in a range of cool tones (fig. 123).

In the completed painting (fig. 124), notice how the use of chromatic tones creates well-defined shapes on the model's body.

Fig. 121. Darkening contours gives the model's body greater volume.

Fig. 122. Using a wide brush loaded with ultramarine blue, Merche paints the background, pushing the figure forward in strong relief.

123

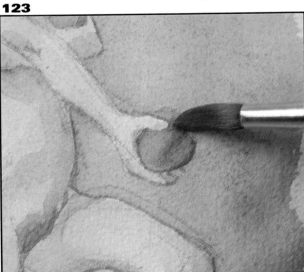

124

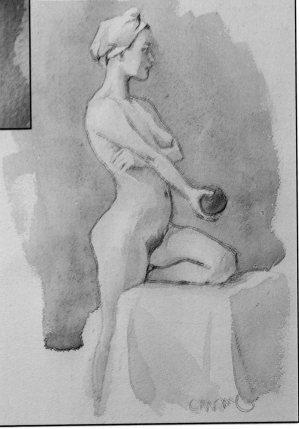

Fig. 123. The apple is painted in just a few seconds, bringing a warm note of colour to a sea of cool tones.

Fig. 124. The final work is completed with Merche's usual technical skill.

TIPS

Clean your brushes carefully to keep colours pure and bright.

Always evaluate your progress by stopping from time to time to look at your painting from a distance.

Drawing and Painting Facial Features

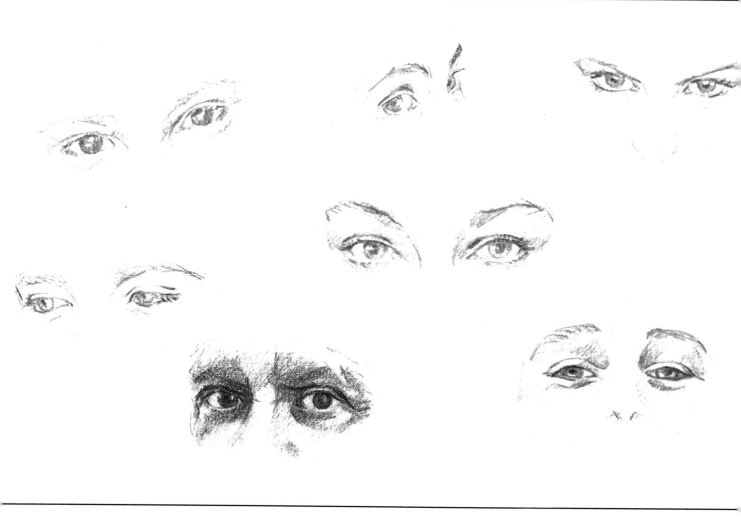

To paint a portrait successfully, it's important to practise drawing and painting individual facial features, so the exercises on the next few pages concentrate on depicting eyes, eyebrows, nose, ears, and mouth. Using pattern number 2, follow the instructions and illustrations prepared by Merche Gaspar for this group of studies.

Before starting to draw the eyes, it's important to remember that eyeballs are spherical which means that whenever the eye isn't looking straight ahead, the effect of foreshortening will give the iris a more oval shape. Understanding this basic principle, draw the eyes of various people looking in different directions (fig. 125). Paying attention to details, you'll see that when the eye is open, the curve of the upper eyelid is tighter than that of the lower eyelid. Also, if the muscle above the eyelid is tense, we can clearly identify the curve of the eyelid; otherwise, this arch will be hidden under the skin above the eye.

Fig. 125. Practise drawing eyes seen from many different perspectives, as in these sketches using men, women, and children as models.

126

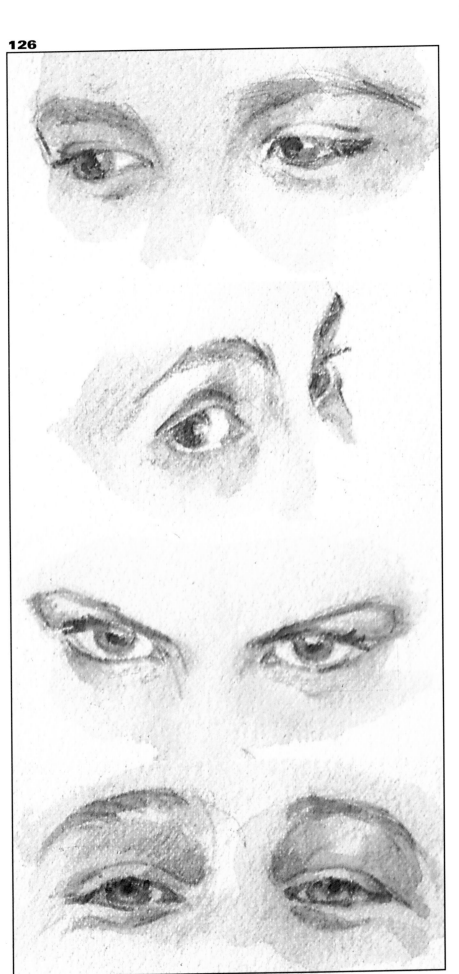

Merche's next step is applying a base wash of diluted raw sienna and vermilion on four of her previous drawings (fig. 126).

Then she works quickly, accentuating the darker areas of the eyelids, eyebrows, and inner corners of the eyes by adding diluted burnt umber on top of her base colour.

When painting the irises and pupils, she leaves some spots uncoloured to simulate the characteristic highlights seen there.

Naturally, chromatic gradations will vary depending on the eye colouring of each model you work with.

Comparing Merche's finished studies with your own will be helpful in guiding you through this exercise when you try it again. By varying models and their eye positions, you'll reinforce your skills at portraying what many people consider to be the single most important component of a facial portrait: expressive eyes.

Fig. 126. Diluted colours are used to accentuate and give volume to these drawings. Secondary washes, superimposed on the base colours, bring out highlights, shadows, and reflections.

TIPS

It's sometimes a good idea to colour the white of the eye slightly so as to avoid too great a similarity with the colour of the paper.

Remember that since the eyes are located on the curved surface of the face, we can only see them as two identical shapes when looked at head-on.

Begin the nose the way you did the eyes, by making pencil drawings of different noses seen from different perspectives. Merche's examples show one in three-quarters position and two in different frontal positions (fig. 127).

Drawing a nose in profile is usually easiest, but when drawing a nose head-on, you must take into account not only length and depth, but also the shape and size of the tip of the nose and the shadows and highlights that give volume to the sides. I suggest you spend time copying noses from fine drawings and paintings, as well as working with live models.

As in the previous exercise, Merche uses a very limited palette to paint the noses: raw sienna and vermilion, with cobalt blue added for shadowing (fig. 128).

Figs. 127, 128. Practise drawings of noses are sketched in pencil, then painted with a very simple palette of colours to establish the play of light and shadow.

127

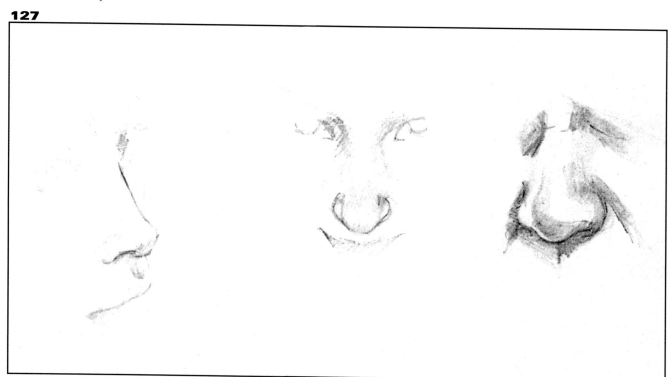

128

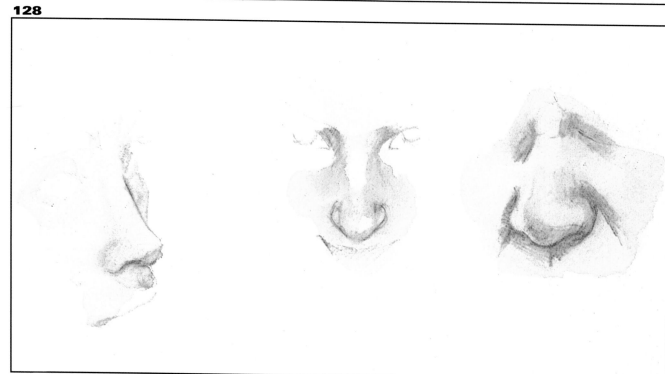

Now let's have a look at ears, a part of the head that painters often don't pay much attention to, but which need to be studied if they are to be portrayed realistically.

As with her previous studies in this group, our teacher draws ears in detail and from several perspectives (fig. 129). Follow her example when preparing your first step for this exercise.

When you go on to use watercolours on your studies of ears, be mindful of different planes and qualities of shadow (fig. 130). First, apply a coat of raw sienna and vermilion to cover up the white of the paper. Add a little ultramarine blue to the wash to finish the parts in shadow. Keep in mind that the hollow of the ear shouldn't be too dark; it shouldn't look like a hole, but like a deeper level, or plane.

Figs. 129, 130. The purpose of doing these exercises, which should be repeated many times, is to familiarise yourself with the intricacies of facial features so that you'll be able to draw and paint them with greater ease and accuracy.

TIPS

In painting a nose, perceive it as a group of lighted areas and shadows, rather than trying to depict specific contours.

Study your own nose in front of a mirror and draw it from different perspectives.

129

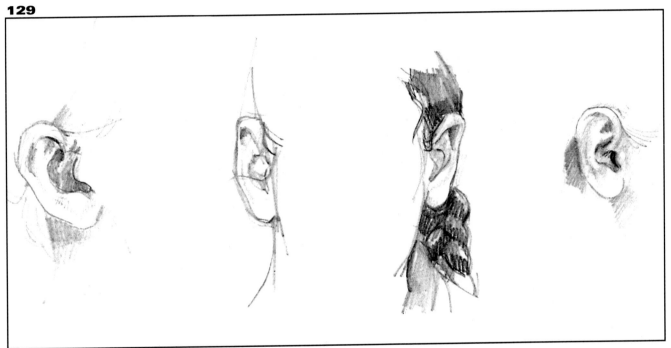

130

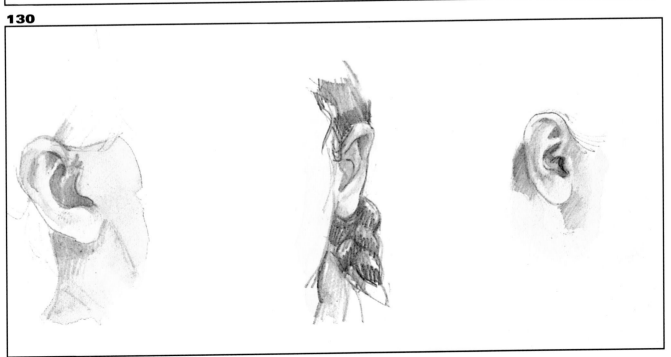

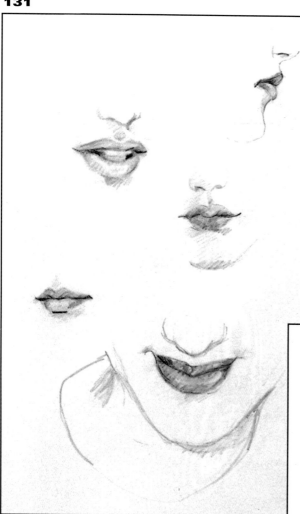

Figs. 131, 132. The mouth, a most expressive facial feature, is illustrated here in several different positions. Paying special attention to the corners of the mouth and curves of the lips will help you to achieve likeness in your portrait paintings.

132

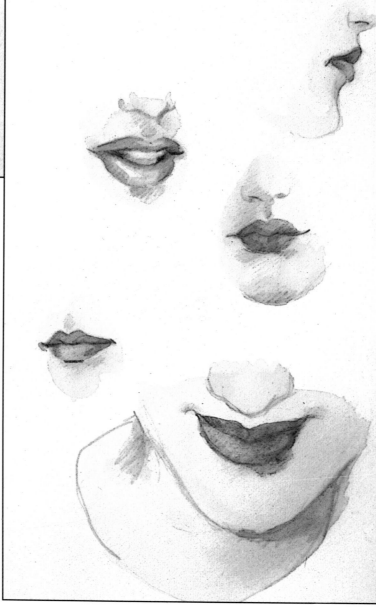

Let's turn to the mouth. Along with the eyes, it's the most expressive part of the face. In her sketches, you can see that Merche gives volume to the mouth by having her pencil express a range of tonal values (fig. 131). Drawing the mouth and the lips, she also includes the lower part of the nose, and in one study, the chin. Follow the artist's lead and keep going with your pencil as you model the shadowed parts.

If you start observing lips closely when drawing them, you'll discover that there are many different types: thick, thin, wide, narrow, fleshy, flat, angular, rounded, etc. Try to capture the distinctive structure of each pair of lips in your portraits.

Now, take a brush, as Merche does, and cover each of your drawings with the same diluted wash used earlier for skin tone (fig. 132). Next, use vermilion and red carmine with just a touch of ultramarine blue for painting the lips. Look at the artist's way of creating small areas of shadow below the nose and mouth and how she accentuates the tonal difference between the upper and lower lips. Under normal lighting conditions, the upper lip is always more shadowed than the lower lip.

133

For the final entry in this exercise group, we have two full-face drawings, enabling you to practise the points made in the preceding studies of individual features.

The winking expression in the first example (fig. 133) is based not only on one closed eye, but on the resultant distortion of the nose and mouth when one eyelid is shut, illustrating how facial expressions vary constantly with the movements of features.

An upturned chin, lips, and closed eyes present another expression (fig. 134) for you to practise as you work on perfecting your portrayal of facial features.

134

Figs. 133, 134. Once you've studied individual facial features, try sketching a variety of facial expressions. Follow these lively examples produced by the interplay of eyebrows, eyes, and mouth. As the relative position of each changes, so does the expression.

TIPS

Leave a spot or two of white highlights on the mouth in a portrait to convey the impression that the lips are moist or wet.

If the teeth look too white, contrasting excessively with other colouring of the mouth, tone them ever so slightly with a very translucent bluish wash.

Painting a Nude Figure

135

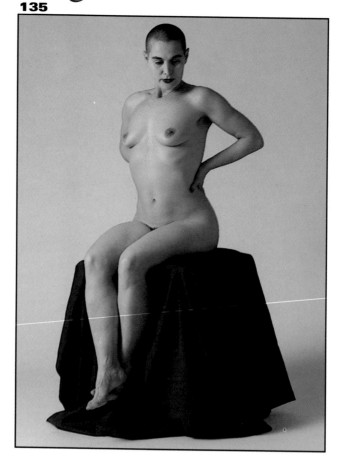

Working with a posed model (fig. 135), now Merche Gaspar paints a female nude. Follow this exercise by using pattern number 3, which replicates the pencil sketch shown here.

By positioning the model seated on a platform draped with a blue cloth, the artist builds a contrasting colour into the scene. The model places her hands on her hips and flexes her back, animating the pose somewhat.

Merche starts by making a drawing with a #2 pencil (fig. 136). Choosing to have the figure command a vertical format, she places the head near the top of her paper, with the tip of the toes nearly reaching the bottom of the sheet. Her drawing of the figure begins with a simple oval for the head on which she marks the location of eyes, nose, and mouth. From there on, her pencil slides rhythmically from the top to the bottom of her paper until she has created a flowing and sinuous outline of the model's form.

Follow along with the artist and begin applying a soft, neutral wash to pattern number 3, simulating the skin tone shown here (fig. 137). While your paper is still wet, indicate the first of the shadowing, using a mixture of brown and just a little carmine red. Notice that when you paint on top of wet watercolours, the blotches blend together and dilute the previous colour.

Fig. 135. After trying several poses, the model adopts a seated position, flexing her back as her hands rest at the waist.

Figs. 136, 137. The initial drawing, made with a #2 pencil, can still be seen under the very pale wash laid down over it.

136

137

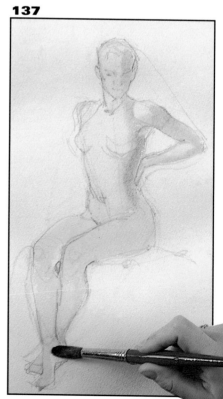

70

138

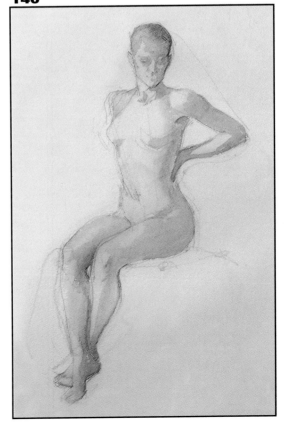

In this next step, colour is represented by just a few tones and is applied fairly quickly (fig. 138). Areas in half shadow are painted with slightly darker glazes. It's a matter of intensifying the tones little by little. But keep in mind that it's better for a watercolour to look underpainted than overpainted, so more tonal gradation is added very subtly to shadowed areas only (fig. 139). The top of the head and areas in half shadow on the body are painted with a pale mix of brown and orange (fig. 140).

Figs. 138–140. Merche continues painting shadows on the body, accentuating its volume through generalised washes.

139

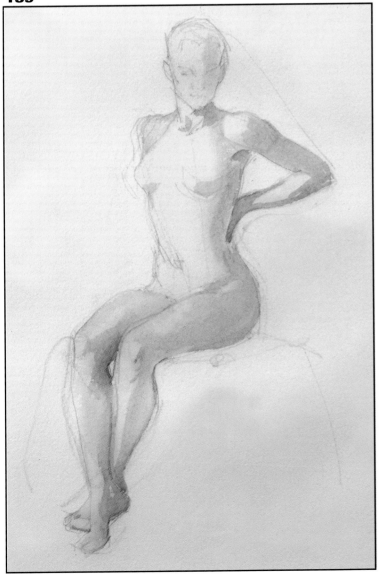

140

Keep in mind that a drawing of this kind is not a portrait, so don't try to bless the facial features of the model with more attention than is needed. Merche just works on the shape, volume, and tones of her model's face, using a brush handle as her tool to suggest certain facial contours (fig. 141). Don't worry about achieving likeness, and definitely avoid detailing every feature. The face shouldn't compete with or contrast sharply with the figure, which ought to be the focal point that attracts the viewer's eye first (fig. 142).

In her next step, Merche paints in the drape on the platform (fig. 143), using a mix of ultramarine blue with a bit of brown. She shows the volume of the head in two tones, which clearly distinguish the lighted half of the face from the shadowed half. With a diluted raw sienna and just a little ultramarine blue, she paints a shadow on the model's shaven head.

Merche's expression as she paints is one of maximum concentration. She repeatedly raises her head to look at the model and then looks back down to compare the real image with the watercolour she's painting. She refines specific anatomical details as the painting develops, shaping the breasts, molding and tinting the nipples a pinkish tone, describing the navel.

Now the artist stops. She waits a few minutes until her paint dries, to make sure the colours are right. Follow her lead and pause when you reach this stage, let your paint dry, then step back and see how everything looks. Remember that when watercolour dries, it tends to look paler and lighter than when you applied it, so if you want deeper tones in your final painting, another glaze or two may be needed.

141

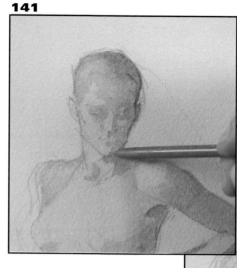

142

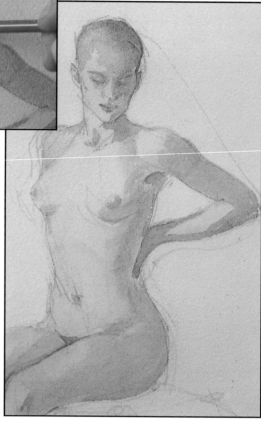

Fig. 141. She unifies the facial features by spreading a uniform wash over them, and while it's still wet, uses her paintbrush handle to outline and detail certain areas.

Fig. 142. A delicate pink wash is applied to the nipples and lips of the model.

143

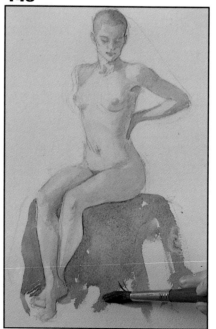

Fig. 143. Merche begins spreading a blue wash over the platform drapery.

TIPS

Try to work quickly, but pause every twenty minutes or so to give your model a rest.

In the classical tradition, it is thought to be more challenging to make detailed anatomical drawings and paintings of full-figured female models rather than very thin ones.

When posing models, choose natural, relaxed positions.

Whenever possible, avoid copying photographic portraits, which are often very formal. Working from a live, three-dimensional figure offers much more information than a flat, two-dimensional photo.

144

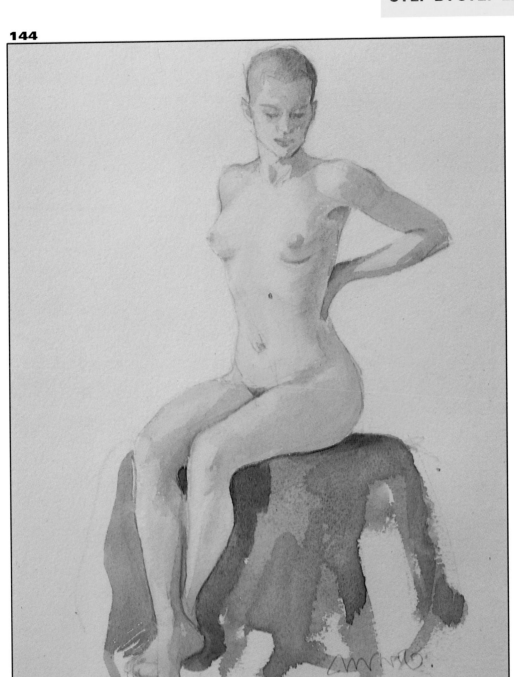

In Merche's final work (fig. 144), we see a well-proportioned, correctly constructed painting with perfectly harmonised colours. The model's downward glance imparts a gentle and serene aura.

You may be tempted to give a watercolour of this simplicity more detail, to depict shapes and colours more fully or to make the facial resemblance more concrete. Resist such temptations. Too much mixing or layering of colours could end up muddying values, which will then become more opaque, and too much coverage won't allow some white of the paper to breathe through. Watercolour paintings lose their brightness quickly when overworked.

If you have problems drawing a model's pose, I assure you that the secret for portraying the figure successfully is fairly simple: sketching it inside a geometric form. That form—usually a triangle, square, or rectangle—should be clear after you pose the model. For example, can you see the triangular form in the above painting?

Fig. 144. With a little shadowing added to the drapery and a few more details given to the face, this fine watercolour nude is now completed.

Painting a Clothed Figure

For this demonstration, artist Ester Llaudet seats her male model on a high stool with his body facing front. Following the advice that Ingres gave to his students—that the body and head should be orientated in different directions in a figure portrait—Ester has the model turn his head slightly to the side in a three-quarters position (fig. 145).

The source of light is from the left. Ester sits directly in front of the model and studies him for a good while before starting to sketch, examining colours and contrasts of light and shadow.

Then, with a #2 pencil, she makes a simple line drawing (fig. 146), which you'll find replicated on pattern number 4. Using that pattern, start painting the face by layering successive washes of raw sienna with some vermilion in the lighted area, and burnt umber with just a little Prussian blue in the shadowed part (fig. 147). The eyes are just barely indicated at this point.

But in the next step, in addition to adding more skin tone, Ester works on the eyes, which she believes is where the soul of all good portraits resides (fig. 148). She tells her students that if you can capture the model's precise eye expression, a good, overall likeness is sure to follow. Towards this objective, note how careful the artist is in portraying the corners and shadows around the eyes. To keep her colours pure and her brush free of excess moisture, she wipes her brush often on a paper towel as she works.

145

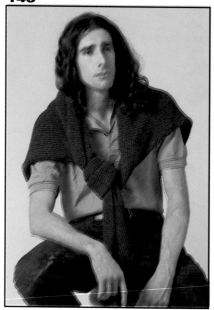

Fig. 145. Posing the model front ways with his head turned slightly to the side sets a casual mood for this portrait.

Fig. 146. A careful initial drawing establishes a detailed foundation for a watercolour portrait.

Fig. 147. The volume and contours of the face are defined through washes indicating gradations in tone.

Fig. 148. The eyes are painted by applying blotches and strokes of colour, one after the other, until a nearly exact likeness is achieved.

146

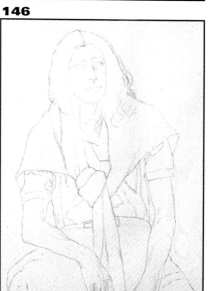

147

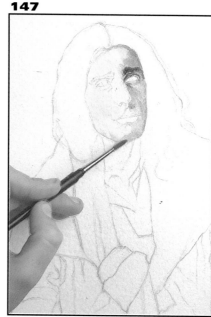

148

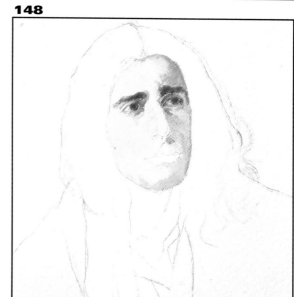

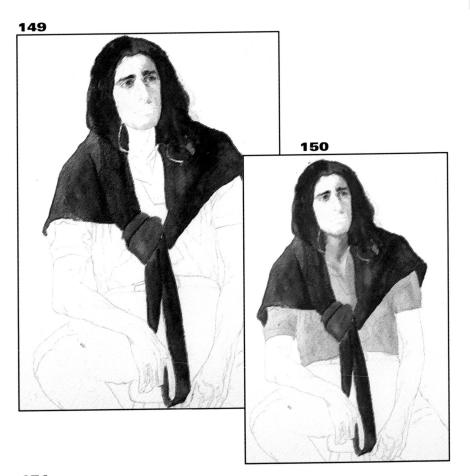

149

150

Now the model's sweater is painted with a mixture of ultramarine blue, carmine red, and Van Dyck brown. For the hair, use the same thick colour, but add more brown (fig. 149).

As you can see, this artist's method is to concentrate on one part of the painting, then another, using successive washes until the image emerges like a jigsaw puzzle being pieced together. She chooses a pale wash of ultramarine blue for the shirt, then with a little Prussian blue and sienna she paints the neck, using three different values of the mixture (fig. 150).

Now the arms are painted with the same mixture used on the face (fig. 151). Notice how the casual placement of the model's arms forms a composition of its own, bringing a well-balanced optical weight to the whole picture.

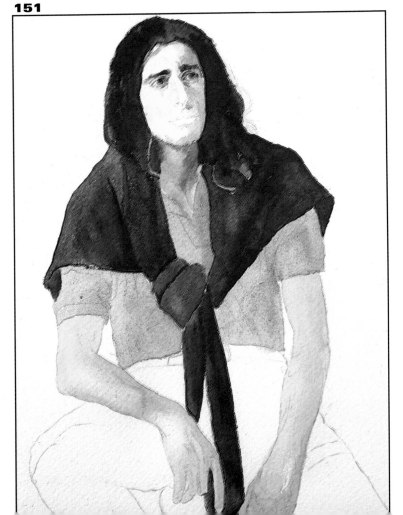

151

Fig. 149. As the work proceeds, white spaces on the paper are covered with new tones in a constant search for the best ones.

Fig. 150. The artist works very spontaneously, applying some flat washes without gradations of tone or a show of light and shadow.

Fig. 151. The casually placed arms are painted with successive washes to impart a sense of volume and contour.

After giving the model a short break, Ester resumes working. Using a #6 brush, she paints the trousers with a single tone, almost completely devoid of tonal gradation (fig. 152). She finishes this step by covering the white space in the background with a bluish grey obtained by adding water to the mixture left over from painting the shirt.

After washing her brush, Ester picks up a little carmine and red from her palette and gives a pinkish touch to the lips, then retouches and details the model's facial features (fig. 153).

Since the shirt has only a basic, flat wash on it, it's time for Ester to shade the fabric lightly, indicating its folds and contours. She does so by layering a somewhat darker glaze of the same colour on top of the initial wash, which has already dried (fig. 154).

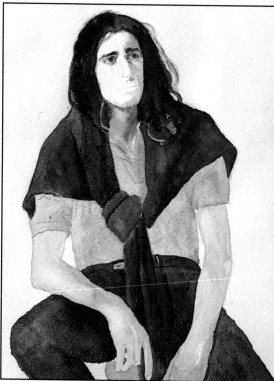

Fig. 152. After the background has been toned lightly, the artist continues to develop the face.

153

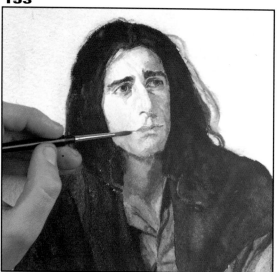

154

Fig. 153. This close-up of the face gives you a better look at the artist's fine brushwork and how well it reflects the model's persona.

Fig. 154. Contours and volume are defined further through successive glazes of tonal gradation on the arms, shirt, and sweater.

155

Notice the important role played by the model's arms and hands in reinforcing the contemplative expression on his face. In detailing the hands, the artist builds them up with successive glazes of burnt sienna. Notice that the flat mass of colour on the arms has now acquired volume through gradual layering (fig. 155).

After a last step in which the texture and intermediate tones of the shirt were added, the exercise is complete. You may have noticed that the painter has taken some liberties with the general range of colours by making them lighter than those in the photo, especially on the model's face.

In this portrait of a clothed figure, Ester has met three goals she set for herself, which you should aim for as well. The first is artistic quality: a watercolour that engages the viewer's interest through its good drawing, composition, and agreeable palette of colours. The second goal is resemblance to the model, which Ester has certaintly achieved. The third is the portrayal of textures in the model's clothing: differences between fabrics of the trousers, shirt, and sweater are successfuly depicted.

Fig. 155. Both accurate resemblance to the model and his contemplative mood are certainly reflected in Ester's completed portrait.

Painting Groups of Figures

When we draw or paint an urban space, we usually find it full of people—some walking, others seated talking, reading, or enjoying the sunshine. Artists have included figural groups in cityscape and even landscape paintings for centuries. Impressionists often described each figure with just three or four brushstrokes.

This exercise teaches how to capture a scene in just that way, indicating figures rather than detailing them precisely. Once again, we call on the talents of Merche Gaspar, this time to lead us through her painting of sunbathers on the beach in Palamós, a resort in northeastern Spain that attracts many summer tourists (fig. 156).

She uses a #2 pencil to make a rough sketch of the scene (fig. 157), eliminating many details. When you do an exercise like this outdoors, start as Merche did by drawing people in the foreground who are seated, since they usually stay in the same position longer. Then sketch standing and moving figures with as few lines each as possible to suggest general body position, especially when portraying people in the middle ground or background of your composition.

Using a #2 brush, cover the sky with a light wash of ultramarine blue, manganese blue, and vermilion (fig. 158). Put a bit more red to get violet in your mix for the upper part of the sky.

156

157

158

Fig. 159. She paints the houses, bell tower, and other undefined background shapes with thicker washes.

159

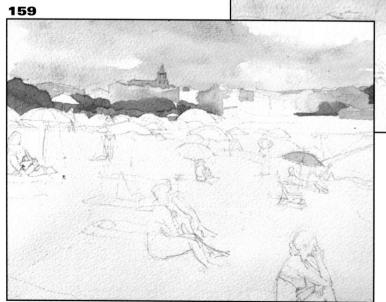

Fig. 156. This photo was taken on a popular beach in Spain.

Fig. 157. The artist's sketch simplifies the scene considerably.

Fig. 158. A violet sky, painted with a light wash of blue and red tones, is the artist's starting point.

160

161

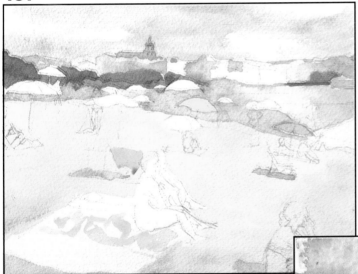

Referring again to the photo on the opposite page, note that distant colours are within the cool range, while warm colours predominate in the foreground. So the church and bell tower are painted with a cool manganese blue and sepia brown mixture; the houses and roofs with touches of sepia and violet (fig. 159, opposite).

Moving to the foreground, the artist uses a wide brush to apply a diluted ochre wash (fig. 160), so that it barely covers her pencil sketch, which will remain present throughout this exercise to provide guidelines for the figures. Merche covers much of the blank space of the paper, but she leaves the group of figures in the foreground unpainted, planning to work on them later.

Now she touches manganese blue lightly to the sea, in the background on the right (fig. 161), then paints the parasols and towels, describing each in a single diluted layer of flat tone.

Working on figures in the middle ground, the artist uses just a few brushstrokes to describe skin tones and swimsuits (fig. 162).

162

Fig. 160. Now the sand is toned with a very diluted ochre wash applied with a wide brush.

Fig. 161. The artist adds more colours to the scene, applying touches of yellow and carmine to the beach umbrellas and towels.

Fig. 162. She uses a finely pointed brush to tone figures in the middle ground.

While distant figures are portrayed with minimal brush-work, note that many parasols and other faraway, unde-fined details are left completely white, to give luminosity to the scene (fig. 163).

Returning to figures in the middle ground, looseness still governs Merche's brushwork, but these figures are executed more concretely (fig. 164). Skin tones include shadows and highlights, to build volume. Learning to paint figures with this degree of ease requires a lot of practice. Note how the figure on the right shows movement, shape, and colour, all achieved with minimal brushwork.

Also note that there are no facial features on any of the figures, so don't waste time trying to characterise individu-als in a scene such as this.

Still working in the middle ground, Merche defines more figures and adds a bright accentuation to the picture by showing a bit of a breezy red-and-white striped beach parasol at far right (fig. 165).

For skin tones of figures in the fore-ground, the first wash to apply is a blend of raw sienna with a bit of ver-milion (fig. 166). While this coat is still wet, add burnt umber to indicate shad-ows. Since the closest figure on the right is under the shade of an parasol, she is given a darker, shadowed skin tone.

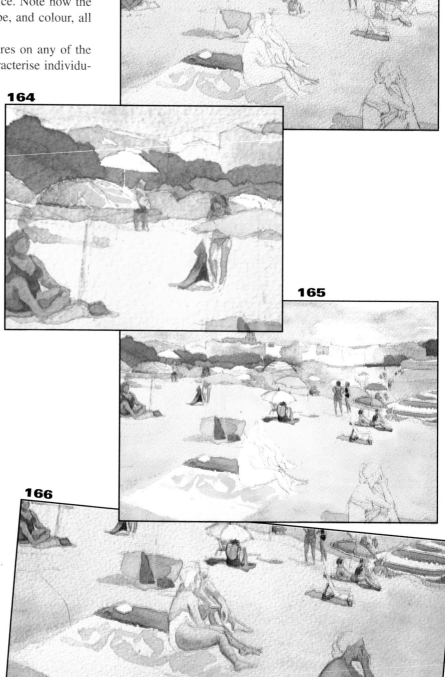

163

164

165

166

TIPS

Figures in the foreground are drawn and painted larger and in more detail than those in the mid-dle ground.

Forms in the distance should be indicated with only a few decisive brushstrokes.

Figs. 163–166. As Merche develops one area after another, she's careful not to cover all white spaces, since she plans to retain many in her completed painting. Note that figures in the middle ground are more defined than background figures but less distinct than those in the foreground.

167

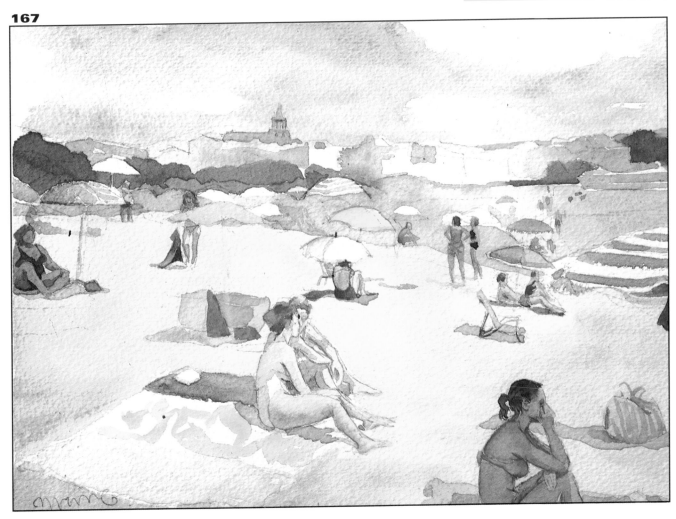

With hair painted on the near group of figures, and facial features vaguely suggested on the nearest ones, Merche's painting is complete (fig. 167).

As the final work shows, the artist has freely interpreted a complex scene by omitting some buildings and figures, modifying colours, and taking other liberties with aspects of the setting shown in the photo.

You'll probably have problems sketching figures when you undertake this exercise working from life, because people do move around a lot in any group scene. If you find that you're unable to finish a figure because the person suddenly changes position, work on another part of the painting, then look again. People tend to repeat the same posture frequently, so chances are you'll soon be able to complete that figure.

My best advice is to work quickly, avoid details, and interpret what you see very freely, giving form to people and objects with a limited number of pencil marks, and later, brushstrokes.

To create a simple, fresh painting, keep your values on the light side, your washes diluted, applied smoothly, with appropriate touches of stronger colour for accentuations and darker values for shadows.

Fig. 167. This completed watercolour painting shows that by eliminating lots of detail and reducing a busy setting to its most important elements, the artist has succeeded in conveying the essence of a sunny beach in a free and fresh way.

Painting a Famous Person

Ester Llaudet, an excellent portraitist, chooses one of film history's most famous stars, Humphrey Bogart, as the subject of this exercise. She works from a colour photograph (fig. 168), and will build her drawing with the help of a grid. Pattern number 5, a preprinted grid, is the sheet for you to use as you follow along.

Using a ruler and T-square, the artist creates a grid on the Bogart photo (fig. 169), which is 6 x 4" (15 x 11 cm) and will then be used as reference in scaling up the image to a larger size on watercolour paper. When employing this method, if you don't want to ruin a photo by drawing on it, make a photocopy of the picture and draw your grid on that instead, or draw the grid on a clear acetate sheet placed on top of the photo.

Ester marks her grid horizontally with letters A through G, and vertically with numbers 1 through 10. Those coordinates are then marked on her watercolour paper (fig. 170). (The coordinates are imprinted on your exercise grid sheet.) This method permits the artist to scale a photo up or down to any size. As long as the content of squares on the drawing matches the content of squares on the photo reference, the size of the subject's facial features and proportions of those features to one another are certain to be accurate in the drawing, and a good likeness is guaranteed.

Using a #2B pencil, Ester starts her drawing at the top and works her way down. As she proceeds, each square corresponds to the photo grid precisely. For example, the eyes, in photo squares 4D and 4E, are placed in those squares in the drawing.

Before painting, normally you would rub out the grid, but since yours is printed on the pattern, it will remain visible throughout this exercise. In Ester's case, she rubs out her grid and applies a quick first wash (fig. 171). Using burnt umber for the lighted parts of the coat and hat, with hardly a pause, she adds a second, sepia tone for the shadowed areas, and with some red added to the mix, paints the bow tie.

168

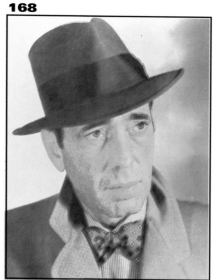

169

170

Fig. 168. The artist's choice for this exercise is a very characteristic photo of Humphrey Bogart.

Fig. 169. A grid is superimposed on the photo and its coordinates are marked from 1 to 10 vertically and from A to G horizontally.

Fig. 170. A grid is drawn on watercolour paper to match the one on the photo.

Fig. 171. Once the basic structure of the painting has been established, the artist rubs out the grid and starts applying washes.

171

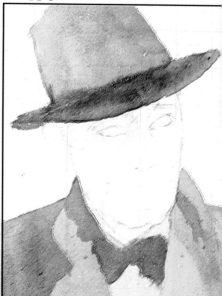

172

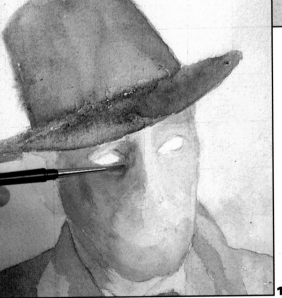

Ester applies a pinkish wash of very diluted vermilion to the face, reserving some white space for the eyes and highlights on the nose and lips (fig. 172). Then she uses a wider brush to cover the background with very subtle gradations of ultramarine blue and lemon yellow brushed on in quite diluted form, allowing the colours to flow together on their own.

Now she develops skin tone by applying a mid-value wash of raw sienna with vermilion to the lighted side of the face and burnt umber with a touch of Prussian blue to the shadowed side (fig. 173). Each wash is applied while the previous one is still damp to the touch, except for the final, darkest accentuatios, which are added once the area is dry.

It's important to note that working with smaller brushes when detailing facial features allows for greater precision and promises greater likeness. Always begin with the eyes when portraying features (fig. 174). As Ingres advised, every portraitist should paint the eyes first, building them up little by little, working on one, then the other. Follow Ester's lead and use thicker paint for the eyes than for the rest of your portrait painting.

173

174

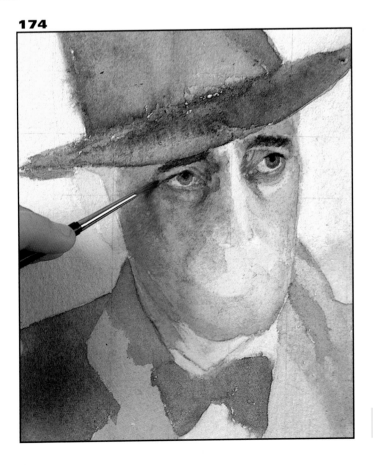

Fig. 172. Very pale washes are applied, with a good deal of white space left unpainted at this point.

Figs. 173, 174. The shadowed side of the face is painted next, and then the eyes. Shaping the eyes and the position of the lids in relation to the iris are very important steps in achieving a good likeness.

With the characteristic expression in Bogart's eyes now fullly captured, there's just one remaining detail: shadowing the whites of the eyes with a very diluted brownish wash (fig. 175). Without this touch, the paper white would be too glaring a contrast with the rest of the face.

Before moving along to other features, Ester adds a little more shadowing next to the bridge of the nose and some darker values on the rim of the hat (fig. 176).

At this stage the portrait still looks a little like a sketch. While the eyes are fully developed, the rest of the face awaits completion. With the same thin brush she used for the eyes, Ester now paints the mouth, using a mixture of burnt umber and a little vermilion (fig. 177). With slow, careful strokes she suggests contours below the nose and on the chin, and accentuates the difference in tone between the lighter lower lip and the darker upper lip, reserving a sliver of white to simulate a highlight. The shadowed side of the coat is also given another layer of dark wash.

175

Fig. 175. With the eyes and nose now successfully completed, resemblance to the model is unmistakable.

Figs. 176, 177. In these last steps, the artist concentrates on refining the expression of the mouth and other details that still need attention.

176

177

TIPS

It's critical that the grids on both the reference photo and the watercolour paper have the same number of squares and be drawn precisely.

Step away from your painting after completing each step in the exercise to compare the tonal relationships in your work with those shown here, making adjustments as may be indicated.

178

For her finale, Ester rectifies tonal values in skin tones here and there, then adds a little texture to the bow tie, collar of the coat, and the shirt (178).

Viewing the artist's Bogart portrait, it's obvious that the likeness is very accurate. How did you do with your rendition? By using the grid to guide you, I suspect that you've managed to achieve a similar result in your own painting, but if you haven't, don't be discouraged. Practise drawing the eyes

on a separate piece of paper as many times as necessary. As you've seen here, the secret to good portraiture lies in the eyes, where the very essence of a person can be seen.

Once you've completed this exercise, try watercolour portraits based on photos of other famous people. By using a grid each time and applying the methods you've learned here, you'll be on your way to building your very own celebrity portrait gallery.

Fig. 178. Looking at the completed portrait, note how expertly Ester created a colourful portrait based on a very limited palette, animated by strong contrasts of tonal values.

Painting an Action Portrait

179

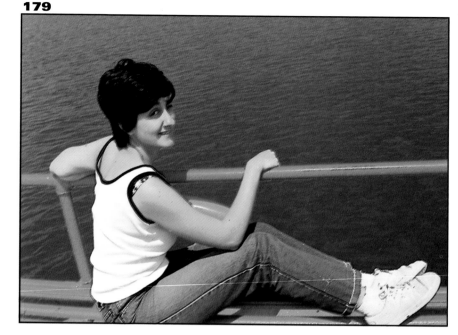

While we usually associate portraiture with still poses, a figure in motion makes lively subject matter to consider for a watercolour painting.

Pere Llobera demonstrates this approach in an exercise using a candid action photo, giving you an opportunity to build on the studies you made earlier portraying a model in various poses. This time, you'll work with a photo that has frozen a moment in time being enjoyed by a friend of the artist during a boat ride (fig. 179). You probably have a good stock of such candid moments to draw from in your own photo albums of family and friends. Such spontaneous pictures are often evocative of works painted by the great masters of Impressionism.

Pere's first step is a line drawing made with pencil strokes that are indistinct but catch the model's body position (fig. 180). Pere explains, "I like to make a drawing that isn't well defined. As I move the watercolour forward, I'll have plenty of time to work on all the details."

Using a #10 brush, Pere applies a first wash of Payne's grey and green to suggest the background water (fig. 181). For the woman's hair, he mixes sepia and ivory black. The skin tone is a very diluted, translucent mixture of burnt umber touched with vermilion.

Fig. 179. This candid snapshot taken by Pere Llobera inspires a lively step-by-step exercise. One of your holiday photographs might also become an excellent model for your next watercolour painting.

180

181

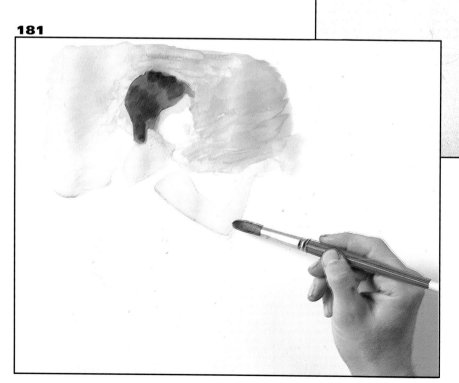

Figs. 180, 181. After making a loose pencil sketch, the artist begins applying pale washes of skin tone, hair colour, and background tint.

182

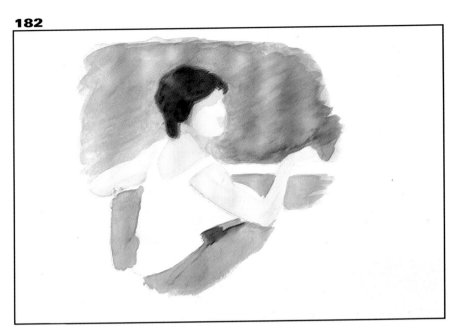

183

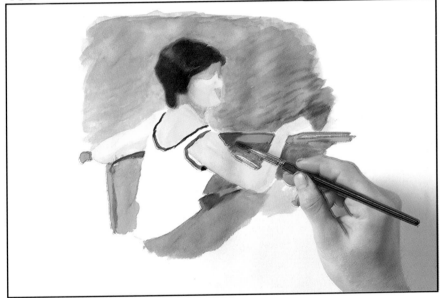

184

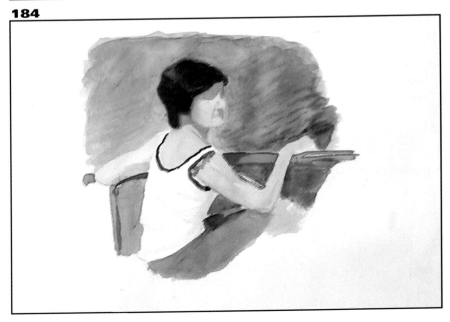

The artist continues working on the background, darkening and spreading out the previous wash, silhouetting the figure carefully (fig. 182). He leaves the model's shirt unpainted for now, but paints the leg of her trousers a blue-grey (ultramarine blue mixed with what was left over from the skin tone).

Now Pere turns his attention to the face. Notice that despite the skin tone having been applied flat, subtle variations on the neck and arms begin to create a three-dimensional effect on the skin (fig. 183). The artist also paints the boat's red railing, using a #6 brush and a thick coat of vermilion, allowing some slivers of white to remain, suggesting highlights on the shiny metal. Then using brown paint, he indicates a few shadows on the railing. His final application in this step is dark blue paint, applied with a fine brush, to describe trim on the model's shirt.

As the artist continues to work, he paints creases and contours in the shirt, using very pale burnt umber and grey (fig. 184). Notice the nice anecdotal touch of having an edge of blue swimsuit stick out from beneath the shirt's right shoulder strap.

Figs. 182–184. A flat coat of colour acts as a base on which successive glazes are placed as Pere builds up tonal values in the background, then works on the model's features, her shirt, and the boat's railing.

Now Pere intensifies the background tones (fig. 185). He creates a sense of depth by covering the background with visible brushstrokes all going in the same direction, a technique that is reminiscent of Impressionist work.

Notice how the model's face has developed gradually. Working little by little, putting down one glaze after another, the artist has given the portrait a range of both lighted and shadowed areas.

At this stage, does your watercolour also show a range of tones? Light and shadow should be portrayed through a limited number of strokes, without overpainting. Because the painting is based on a simple range of colours, built-in contrasts result automatically: the creamy, warm colours of the skin against the striking red of the railing; the white shirt against the cool blue of the trousers and river water (fig. 186).

185

186

TIPS

If you work with coats of colour that are diluted, not thick, the risk of covering the surface of the paper too quickly will be lessened. Thin glazes are easier to change and correct than thick ones.

Keep your palette of colours as simple as possible. The quality of a painting doesn't depend directly on the richness of tones or the range of colours, but on the skill with which they are used to express the shape of an object.

Figs. 185, 186. Little by little, chiaroscuro is enriched by the artist as he adds further contours to the model's face and arms.

187

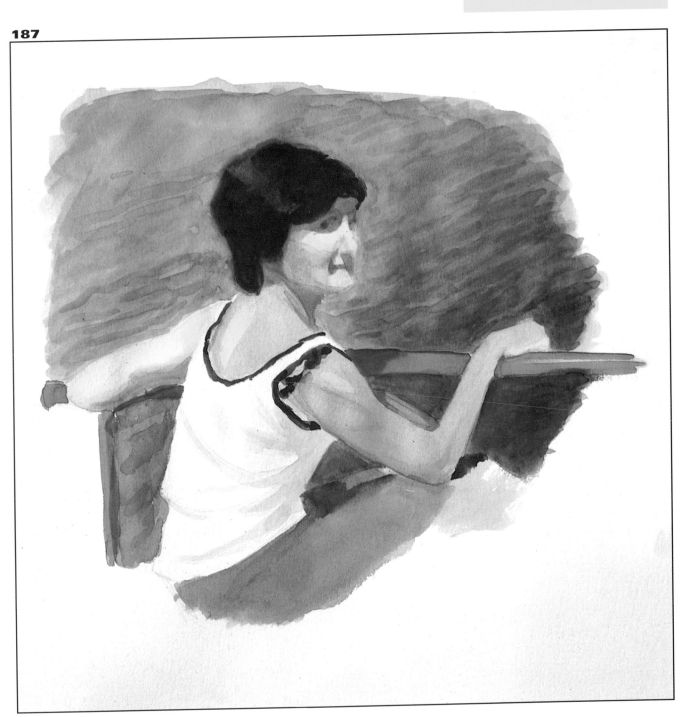

Now there is only one detail left: defining the model's eyes and mouth with careful application of brown tones (fig. 187).

As you compare Pere's final work with the one you've painted, ask yourself if you've taken into account each of the following considerations as you worked:

1. Despite the use of flat washes, the arms should look round, which means you should have applied one value of skin tone on top of the next, moving from light to dark. Such a technique builds contours as shown on the model's arms and face.

2. Observe the role played by the background in making the figure come forward as the focal point of the painting. At the same time, it's important for the figure's colours to harmonise with background hues. Towards that end, add a little skin tone to the background colour to balance and harmonise the two areas.

3. Notice how the artist avoids detailing facial features. His objective is to portray a candid, unposed moment in this portrait, not to reach for exact likeness. After all, artists have an advantage over photographers in being free to omit elements of reality that don't interest them, to control the degree of definition in a painting. I advise you to do the same, to be more focused on capturing the spontaneity and transience of the image than on achieving close facial resemblance.

Fig. 187. As shown in the completed portrait, the spontaneity of an unposed moment has been beautifully portrayed in Pere Llobera's expressive work.

Painting a Child's Profile

The subject of this exercise, Merche Gaspar's portrait of a little girl, gives us a chance to explore two aspects of portraiture that we haven't dealt with as yet: the proportions of a child's head, and painting a head in profile.

The model is posed looking out a window, daylight illuminating her face brightly (fig. 188). Pattern number 6, showing a simplified outline of the girl's profile, is the sheet to use for this exercise.

Merche's preliminary sketch is rendered with a #2B pencil (fig. 189). One continuous line, from forehead to chin, captures the girl's profile. To proportion and place the ear correctly, she aligns the bottom with the child's nostril and the top with her eyebrow. Hair is sketched in loosely, the plait drawn with a few graceful, undulating lines.

Two or three very pale lines indicate the child's hand placed on the window frame.

Using a round #8 brush dipped in a very diluted mixture of raw sienna and ochre, the artist starts painting skin tone on the face and hand (fig. 190). This pale wash is seen on the lightest areas of the face. While it is still wet, she applies gradations of a manganese blue and burnt umber mix on the shadowed side of the face. When that layer is nearly dry, she darkens selected areas further: behind and inside the ear; under the chin.

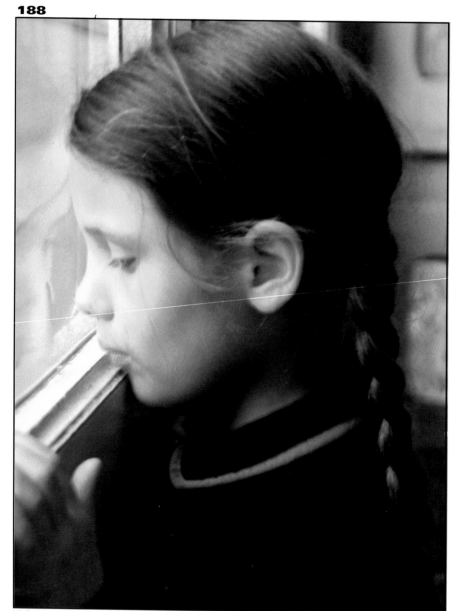

Fig. 188. Caught on film, this pensive moment in the life of a little girl is ideal subject matter for a profile portrait.

Fig. 189. Merche Gaspar's deft pencil strokes achieve resemblance from the start.

Fig. 190. A very diluted wash is applied to the face in tonal gradations that begin to describe the effects of light and shadow.

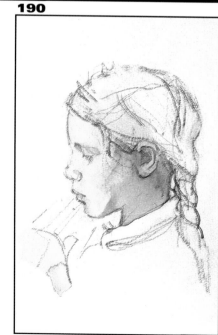

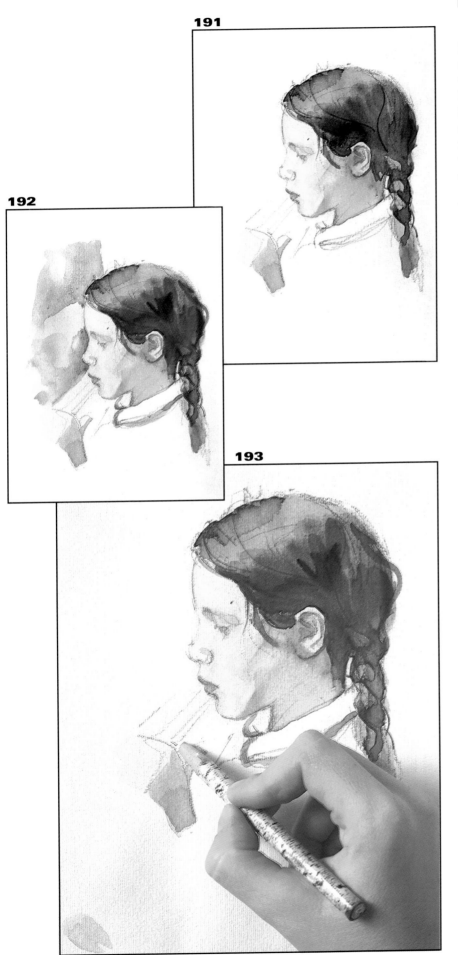

191

192

193

The hair is painted in gradations of Payne's grey mixed with burnt umber (fig. 191). Follow Merche's lead and wait until the lighter values are dry before applying darker shading at the back of the head to define its volume and to describe twists of the braid. Finish this step by suggesting shadows on the hand and giving the lips a pinkish cast.

Now she paints the trim on the blouse collar with a little vermilion. (fig. 192). To suggest window glass, she brushes on a pale wash of Payne's grey mixed with skin-tone leftover from painting the face. Notice how this wash simulates the reflection of the girl's face on the smooth glass surface.

Using a white wax pencil, Merche goes over the few parallel lines that suggest the window frame (fig. 193). Wax acts as a resistant, repelling watercolour, thereby ensuring that the area covered with wax pencil will remain as white highlights on the window frame that will soon be painted in.

Fig. 191. She works on the hair with Payne's grey and burnt umber, using a fairly diluted wash that will be darkened later.

Fig. 192. Now the artist paints the windowpane with an uneven mixture of Payne's grey and skin tone to simulate a faint reflection of the little girl's face in the glass.

Fig. 193. Here Merche uses a wax pencil to reserve some white spaces on the window frame.

Using a wide brush on the rest of the background (fig. 194), Merche paints in a violet-grey wash made of cobalt blue, carmine red, and just a little Payne's grey. She uses the same wide brush on the window frame, resting the edge of the loaded bristles on the paper surface to create a series of parallel lines.

The little girl's blouse is painted with a wash made of ultramarine blue touched with burnt umber (fig. 195). Now the artist returns to the hair, detailing and contrasting the darkest areas. To accentuate light falling on the model's face, Merche touches up darker values on the neck, cheeks, ears, eyes, and lips.

Once the hair is dry, she uses a utility knife to scrape the paper surface and open up white space to simulate light strands of hair (fig. 196).

TIPS

Using a small sheet of watercolour paper for a head portrait such as this reinforces its intimate quality.

Casting the model's eyes downward suggests a private, reflective mood that draws viewers into the picture.

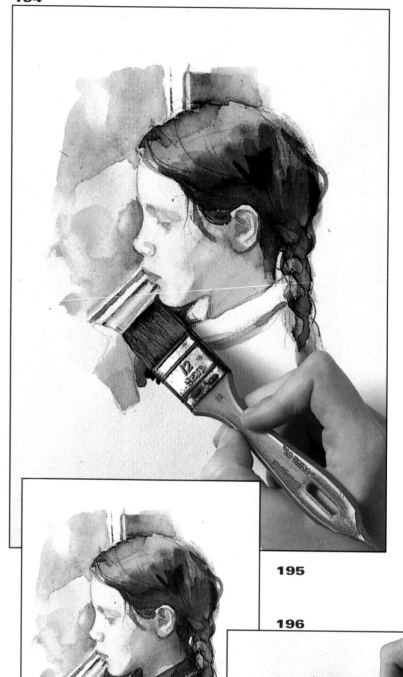

194

195

196

Fig. 194. Merche passes a wide brush over the area where she used wax pencil. The unprotected parts are coloured with a greyish wash.

Figs. 195, 196. After painting in the dress, Merche opens up white spaces in the hair by scraping the paper with a utility knife.

197a

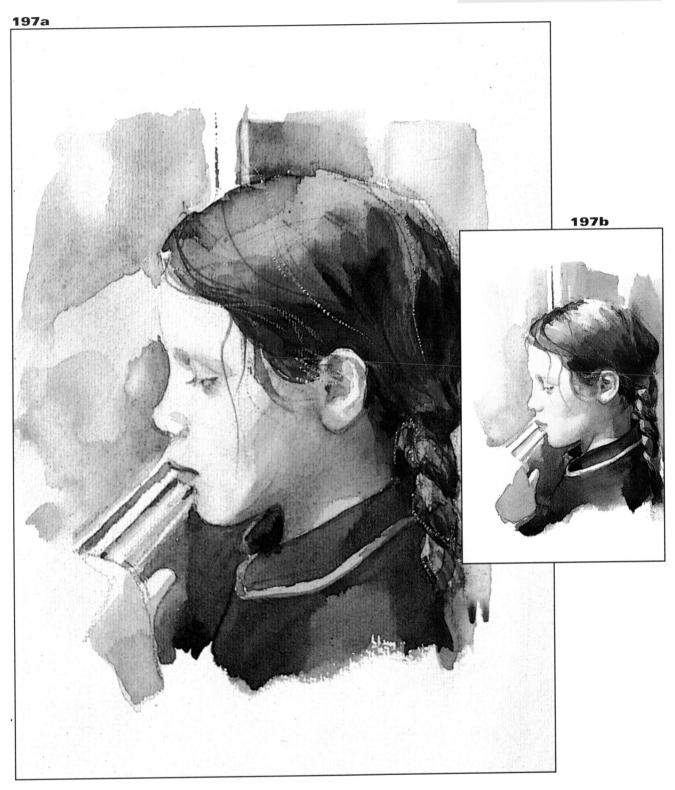

197b

While Merche's painting is now complete (fig. 197a), look at how she has depicted only a small portion of the child's blouse, deliberately leaving it unfinished. This free handling of wardrobe and background focuses attention directly on the portrait and gives the whole painting a flavour of relaxed spontaneity.

In comparing this painting with your own, if you find that yours doesn't have as many striking contrasts in the hair and not as strong a play of light and shadow on the face, it's probably because you weren't able to work as quickly as Merche did in layering glazes before they dried. Don't be discouraged if that happens. It's all right to let a wash dry, then superimpose another wash of a darker colour over it.

Figs. 197a, 197b. A serenity and sweetness come through in the completed portrait, which the artist uses to inspire a series of variations on it, beginning with the small inset shown above.

Glossary

Alla prima: Term adopted from the Italian, referring to the technique of painting in a single session, quickly and without any retouching.

Asymmetry: Strictly speaking, a lack of exact correspondence in composition between the opposite halves of a painting on either side of an imaginary line dividing it. When in a drawing or painting the structure and distribution of the composition is intuitive and doesn't follow any rules, even while a balance of certain masses in relationship to others is maintained, we say that the work shows asymmetry.

Background: The area in a painting that seems to be farthest from the viewer; objects behind the middle ground and foreground.

Backlighting: Contrast produced when the light reaches subject matter from behind, thereby creating dark shadows against a luminous background.

Blocking in: Stating the basic pattern of a composition by drawing in its largest shapes, using simple geometric forms—cubes, spheres, cones, and cylinders.

Buckling: When paper becomes curved or warped as a result of being too wet, a condition that occurs more readily when the paper is thin.

Cast shadow: The shadow cast by one object onto something else in the picture, such as a vase casting its shadow on the table on which it sits.

Chiaroscuro: Italian for "light-dark"; in painting, the technique of modeling form by subtle gradations of light and dark tonal values.

Colour, local: The colour belonging to each object, when unaltered by shadows or highlights.

Colour, reflected: Colour that exists in all objects as the direct or indirect reflection of light and colour projected by other objects.

Composition: The placement of various elements that make up the subject matter of a painting, the objective being to create a balanced, visually appealing, and harmonious arrangement.

Contrapposto: A figure pose often seen in classical Greek and Roman sculpture, where the weight of the body is placed on one straight leg, with the other bent. The torso is twisted in one direction, while the lower body twists in the opposite.

Ferrule: The metal collar on a brush handle that holds the bristles in place.

Foreground: The bottom of a painting, containing subject matter that appears to be closest to the viewer.

Format: The orientation of a painting: horizontal, vertical, or square.

Glaze: Coat of translucent colour superimposed on another colour to intensify or otherwise alter it.

Grain: The texture of a sheet of paper, determined by the distribution and degree of uniformity of the fibres in it. Rough-grained paper is the best for watercolour painting.

Line drawing: In preliminary sketches underlying a watercolour painting, the blocking in of subject matter with lines alone, free of tonal gradation, avoids having extensive pencil marks to mix with and muddy watercolour paint.

Middle ground: Midway between foreground and background.

Modelling: A term used in sculpture, it also applies to watercolour painting in describing the use of different tonal values to create the illusion of three dimensions.

Palette: A portable tray on which the artist sets out and mixes colours. Watercolour palettes have separate box compartments for holding up to two-dozen different colours squeezed from tubes of watercolours. Sets of pan watercolours come with their own built-in palette inside the lid.

Pan watercolours, dry: Small, hard cakes of colour over which a wet brush is run to extract colour that is weak at best; inexpensive, low-quality watercolours best reserved for children's use.

Pan watercolours, semi-moist: Of high quality and wet enough to use with ease, they come in refillable sets with built-in palettes that are very compact and convenient for travel.

Perspective: The representation of three-dimensional space on a two-dimensional surface, so that depth and distance can be portrayed.

Pigment: The colouring agent in paint.

Sable brush: The best brush for watercolour, it has smooth, flexible hair that holds colour well and is very resilient, always retains a good point; expensive but of high quality and long-lasting.

Scale: Proportion; something drawn "one-third" scale is drawn one third the size of the original.

Sketch: Preliminary drawing or painting on which a later, fully developed work may be based.

Texture: Tactile and visual quality presented by the surface of a watercolour painting through its brushstrokes and the grain of the paper, ranging from smooth application, where paper grain barely shows, to loose, dry-brush application on a coarse surface where the paper's grain is quite visible.

Tonal value: The range of lights and darks within a single hue, and the range of lights and darks along the whole spectrum of hues, from the lightest, white, to the darkest, black.

Tone: The prevailing hue in a painting and its comparative brightness or dullness.

Tube watercolours: A creamy, liquid paint that comes in small tubes that can be easily squeezed for filling compartments in a watercolor palette. The form of watercolour paint preferred by most professionals and other serious artists.

Utility knife: A sharp, pointed blade inserted in a handle, this versatile tool can be used to scrape colour off of a dry watercolour painting to introduce white highlights.

Value scale: A gradual range in tone, from lightest to darkest, with no brusque transition from one end of the spectrum to the other.

Wash: Colour diluted with water and applied in a thin, transparent layer.

Permissions

The author wishes to thank the following for use of photographs.
(Works are listed in order of their appearance in the book.)

Doryphorus, Polyclitus. Museo Nazionale, Naples.

Saint Sebastian, Boticelli. Staatliche Museum, Berlin.

Appolo Belvedere, Leocares. Vatican Museums, Rome.

Nude Girl with Black Hair, Egon Schiele. Graphische Sammlung Albertina, Vienna.

Écorché, Jean-Antoine Houdon. École Nationale des Beaux Arts, Paris.

Portrait of a Young Lady, William Merritt Chase. Private collection.

Self-Portrait, Jean-Auguste-Dominique Ingres. Fogg Art Museum, Cambridge, Massachusetts.

Odalisque, Jean-Auguste-Dominique Ingres. Museo Bonnat, Bayona.

Portrait of Sir John Godsalve, Hans Holbein. Royal Library, Windsor Castle.

Self-Portrait, John Singer Sargent. The Brooklyn Museum, New York.

Woman Sewing, Winslow Homer. Corcoran Gallery of Art, Washington, D.C.

Nude, Egon Schiele. Historisches Museum der Stadt, Vienna.

The Sleeping Girls' Nightmare, Johann Heinrich Fuseli. Musée des Beaux Arts, Zurich.

Portrait of Mustafá, Théodore Géricault. Louvre, Paris.

Blue Nude, Edvard Munch. Munch-Museet, Oslo.

Nude, Pierre Bonnard. Private collection.

Acknowledgments

The author of this book is grateful to the following individuals and businesses for their collaboration on the publication of this volume in the Techniques and Exercises series. Thanks to Gabriel Martín Roig for his contributions to the text and for the general coordination of this book; to Antonio Oromí for photography; to Vicenç Piera of the Piera firm for his advice about tools and materials for painting and drawing; to Manel Ubeda of the Novasis firm for the layout and design; and, most particularly, to the artists Bibiana Crespo, Merche Gaspar, Ester Llaudet, Pere Llobera, and Ginés Quiñonero for providing the step-by-step exercises.

A

B

	A	B	C	D	E	F	G
1							
2							
3							
4							
5							
6							
7							
8							
9							
10							